IMAGES
of America

SEATTLE'S WATERFRONT

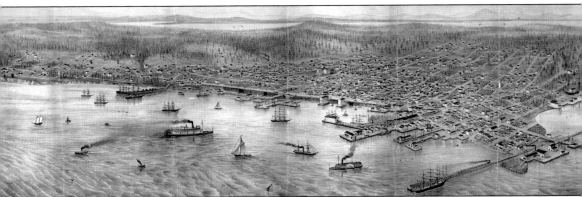

BIRD'S-EYE VIEW OF THE WATERFRONT, 1904. Seattle's central waterfront, Pioneer Square, and the area now known as SoDo—or South of the Dome (i.e. Kingdome, opened in 1976 and demolished in 2000), which was originally a marshy estuarine tideland—are illustrated in this 1904 image. The image also shows two railroads that delivered coal and timber to Seattle's waterfront (the Seattle & Walla Walla Railroad and the Seattle Coal and Transportation Company Railway), as well as the Oregon Improvement Company coal bunkers that were critical to the energy supply line for ships. Seattle's original banks are visible to the north, while the southern shoreline had already been altered since its initial settlement in 1852. (Courtesy Washington State Historical Society.)

ON THE COVER: Smith Tower, once the tallest building west of the Mississippi, rises above Seattle's waterfront in this c. 1940 photograph, which was taken sometime before construction began on the Alaskan Way Viaduct in 1949. The piers along the shoreline were essential for loading and unloading vessels and served as economic mainstays for decades. (Courtesy Seattle Public Library, shp-20047.)

IMAGES
of America

SEATTLE'S WATERFRONT

Joy Keniston-Longrie

ARCADIA
PUBLISHING

Published by Arcadia Publishing
Charleston, South Carolina

Printed in the United States of America

Library of Congress Control Number: 2013944843

For all general information, please contact Arcadia Publishing:
Telephone 843-853-2070
Fax 843-853-0044
E-mail sales@arcadiapublishing.com
For customer service and orders:
Toll-Free 1-888-313-2665

Visit us on the Internet at www.arcadiapublishing.com

*Dedicated to past, present, and future people
who interact with Seattle's waterfront*

CONTENTS

ACKNOWLEDGMENTS

Special thanks go to: Daniel Anker, Mary Azbach, Sally Bagshaw, Rick Chandler, Rick Conte, Bob Donegan, Doris Keniston Driscoll, Jodee Fenton, Ann Ferguson, Leonard Forsman, Hanna Fransman, Leonard Garfield, Sandra Gurkeweitz, Edith Hadler, Paula Hammond, Cecile Hansen, Julie Irick, John Lamonte, Dennis Lewarch, Carolyn Marr, Brandon Martin, Jennifer Ott, Randi Purser, Chad Schuster, Lydia Sigo, Vicki Sironen, Jared Smith, Janet Smoak, Peter Steinbreck, Erin Tam, Diana Turner, and Tracy Wolfe.

The following organizations provided images for this book and have been abbreviated throughout as:

Alaskan Way Viaduct (AWV)
Bainbridge Island Historical Society (BIHS)
Duwamish Indian Tribe Museum (DIT)
International Longshore and Warehouse Union (ILWU)
Museum of History and Industry, Seattle (MOHAI)
National Marine Fisheries Service (NMFS)
National Oceanic and Atmospheric Administration (NOAA)
Puget Sound Marine Historical Society (PSMHS)
Seattle Municipal Archives (SMA)
Seattle Public Library (SPL)
Seattle Tunnel Partners (STP)
Suquamish Indian Tribe Museum (SIT)
Tacoma Public Library (TPL)
Talkeetna Historical Society (THS)
US Fish and Wildlife Service (USFWS)
US Geological Survey (USGS)
US Library of Congress (USLOC)
University of Washington Special Collections (UWSC)
Washington State Archives (WSA)
Washington State Department of Transportation (WSDOT)
Washington State Historical Society (WSHS)
Washington State University Manuscripts, Archives, and Special Collections (WSU-MASC)

INTRODUCTION

Located on the shores of Elliott Bay on Puget Sound, Seattle's waterfront has played an important role in history. Puget Sound was known as the "Whulge" by the Coast Salish tribes that occupied its shorelines. Puget Sound has also been referred to as the "Salish Sea." Seattle has many miles of marine, estuarine, and freshwater waterfronts. This book primarily focuses on Seattle's central waterfront and the area south of Pioneer Square, now known as SoDo due to significant changes along the shoreline of what was once a marshy estuarine area. Seattle's waterfront represents different things for different people with unique perspectives. Some values are similar and supportive of one another, while others may be mutually exclusive. This introduction presents five different perspectives—from the Suquamish and Duwamish tribes, the transportation and business sectors, and an elected official—on the importance of Seattle's waterfront.

SUQUAMISH TRIBE

The Seattle waterfront is a place of great cultural, economic, and spiritual importance to the Suquamish Tribe. Chief Seattle's father lived across the sound from Seattle at Suquamish, where he raised his son to adulthood. Before contact with Europeans, the shore of Elliott Bay was home to winter villages and other places of ancient tribal use. The people who lived here had strong family connections to the Suquamish, who depended on the salt water for their livelihood, while the upriver groups relied on the Black, White, Green, and Duwamish Rivers to serve as intermediaries to both groups.

Between first contact in 1792 and the first settlers at Alki Point in 1851, Seattle grew and eventually attained his chieftainship. Chief Seattle was now a noted speaker with great influence over neighboring tribes and strong political and economic contacts among government officials and Seattle's first businesspeople. He used his influence to keep many of the Puget Sound tribes from joining the Indian Wars that had erupted after the conclusion of treaty negotiations in 1855, essentially saving Seattle from destruction. It was during this time that Chief Seattle gave his famous speech on the Seattle waterfront. Chief Seattle and his people, many from Elliott Bay, retired to the Port Madison Indian Reservation at his ancestral home of Old Man House after signing the 1855 Treaty of Point Elliott.

The city that bears Chief Seattle's name in honor of his many actions that helped the town attain success continued to be a part of the Suquamish economy just as it had for thousands of years. Suquamish fishermen provided fish and clams for Seattle markets, initially shipping by canoe and later by Mosquito Fleet ferries that stopped daily in Suquamish. The cultural bond between the Suquamish Tribe and the City of Seattle continues primarily through shared reverence for Chief Seattle's gravesite at the Suquamish Tribal Cemetery, marked by Mayor Ed Murray's visit to the grave on his 100th day in office in 2014 and Mayor Greg Nickels's support of gravesite restoration in 2009. The Suquamish people still fish for salmon in Elliott Bay and participate in cultural events in the city, such as the annual Salmon Homecoming on the waterfront.

—Leonard Forsman

Leonard Forsman has served as Tribal Chairman of the Suquamish Tribe since 2005. His passions include tribal education, cultural preservation, gaming policy, and habitat protection. He has served on the Tribal Council for 24 years, worked as an archeologist for Larson Anthropological/Archaeological Services, and is the former director of the Suquamish Museum. Forsman is a graduate of the University of Washington. In 2013, Pres. Barack Obama appointed Forsman to the Advisory Council on Historic Preservation.

DUWAMISH TRIBE

A long, long time ago, before settlers arrived to invade this unique waterway, the waterfront of what is now Seattle was undisturbed, pristine. The natives, the Duwamish—which means "people of the inside"—lived here. The Duwamish went about their routine survival way of life, passing through by their mode of travel in the native canoe. They would go into the surrounding forest, select a certain cedar tree, slide it to the waterfront, and begin carving a canoe. The natives would fish the waters, gathering seafood such as clams, which were plentiful at that time. The natives would build their houses—transitory dwellings, as they lived along the lakes and rivers, where they would pick wild berries and roots. They would cut down cedar trees that grew in the surrounding woods to create shingles for the roofs of their homes. The cedar trees provided materials to make baskets for food, cooking, and storage, as well as clothing and hats.

In the early 1850s, Indian agent Issac Stevens arrived to force the natives to sign treaties of magnanimous promises to natives, especially the Duwamish. As the first signers of the 1855 Point Elliott Treaty, the Duwamish consented to giving up over 54,000 acres of indigenous native lands; however, the treaty's promises proved to be false. In a true tragedy, the Duwamish were forced away from the waterfront to allow settlers to buy the land, shoving away the Duwamish from their native land even before Congress ratified the treaty in 1859. When ships arrived at the waterfront with goods, they dumped their unwanted ballast nearby (Ballast Island, at the foot of Washington Street). Natives were allowed to bring their canoes ashore at this particular location to gather until that site, too, was needed by the settlers.

Today, the waterfront has become a picture of unfeeling chaos. Building a bore tunnel under a city of towering skyscrapers is yet another act of a city that is clueless about the once beautiful waterfront of some 150 years ago. The city leaders have dishonored our leader, Chief Seattle, naming this city after him but forgetting his people who thrived along a beautiful waterfront. Another major and disgusting lack of respect toward the Duwamish by surrounding tribes and in Indian country has occurred during the city's Salmon Days. When our canoe, *Raven*, comes to the city waterfront, we have to ask a maligned Indian group to dock at an ugly pier and come ashore. Sadly, however, there is no shore, just piers sticking out into the waterfront. Question: What do we really honor? This is a connecting narration of past events and a partial history of the Seattle waterfront.

—Cecile Hansen

Cecile Hansen is a descendant of Chief Si'ahl (Seattle) and has served as the elected chair of her Duwamish Tribe since 1975. Under her leadership, the Duwamish Tribe filed an appeal in 1977 to attain official recognition of the tribe, which was granted by Pres. Bill Clinton, only to have it overturned by the George W. Bush administration within hours of his inauguration in 2000. Hansen continues to persevere in her pursuit to gain official recognition for the Duwamish Tribe.

TRANSPORTATION

From the time the Vashon glacier carved out what we now call Puget Sound, the unique landscape of Elliott Bay and the lowland shore formed a hub where commerce, culture, and community intersected. Where tribal cedar canoes were once the main form of transportation in the Sound, we now see shipping vessels, ferries, and fishing and recreational boats coming and going throughout the day. On the land side, with a constrained geography but ever-growing development, the network of rails, highways, and city streets compete for space and services to carry the demand for transportation mobility. Seattle's waterfront has seen a variety of uses over the years but has long been a place where the working waterfront is an important part of the local and state economy and an asset for international trade. The need for a well-functioning transportation system is never more apparent than on the Seattle waterfront, which is the confluence of the city's economy, environment, and quality of life. As might always be the case in a community that has grown up over 150 years, the transportation systems have developed in a disparate fashion,

meeting a variety of needs. The Great Fire of 1889 destroyed the core of the city and resulted in a new street system elevated up to 22 feet. The 1950s-era viaduct was built at a time when it was deemed important to keep up with the north-south travel demand with little regard for the barrier it created between downtown Seattle and the bay. As gentrification has nudged against the port and industrial lands, the rail and road access and capacity have become strained. The 2001 Nisqually earthquake was a wake-up call about what we knew of our vulnerabilities for western Washington infrastructure, but this was even more pronounced on the Seattle waterfront. The damaged columns and bents on the Alaskan Way Viaduct reinforced—for local and state leaders and the public—the imminent danger for liquefaction and catastrophic failure to Seattle's seawall, the viaduct, and the city's key electrical transmission lines and high-pressure gas, water, and telecommunications utilities. After many studies and much debate, Gov. Christine Gregoire, Mayor Greg Nickels, and King County Executive Ron Sims made the decision to replace the damaged Viaduct with a deep-bore tunnel to facilitate the mobility of 110,000 vehicles a day, replace the failing seawall, provide community access to the waterfront, and build a parkway along Alaskan Way that reconnects the city to its roots. It is not often that a city has a do-over opportunity like the one that has presented itself on the waterfront. But like the 1889 fire, through collaboration and a lot of hard work, the Seattle waterfront redevelopment will be a long-lasting asset for the city and state and will be enjoyed by many for decades to come.

—Paula Hammond

Paula Hammond served as the secretary of transportation for Washington State from 2007 to 2013. Currently, she is senior vice president for Parsons Brinckerhoff, a global consulting firm that helps public and private clients to plan, develop, design, construct, operate, and maintain critical infrastructure.

BUSINESS

Whenever visitors come to Seattle's waterfront, they call to ask, "What should I wear?"

If you come to work the fishing boats bound for Alaska, bring your rubber boots, polypropylene gloves, and vinyl bib rain gear. Did you know that ships and boats from Seattle's harbor catch and sell more fish than is caught and sold in all other 49 states combined (much of which comes from Alaska)?

If you come to work on Harbor Island or at the Port of Seattle, bring your boots with steel toes, hard hats, and welding glasses. Almost 15,000 people work in or around Seattle's harbor building or repairing ships, unloading containers, fishing, or loading tugs and barges for Alaska.

If you come to vacation, bring your sunglasses and kayak gloves. More and more people use Elliott Bay and Puget Sound to fish, sail, watch whales, or exercise. Almost one million cruise passengers embark and disembark along Seattle's waterfront, and many of them ride Seattle's Great Wheel or an Argosy boat to Tillicum Village. Nearly five million visitors wandered the waterfront last year to view sea otters and octopuses in the aquarium or to get fish for lunch and feed chips to the gulls. If you plan to stay at The Edgewater Hotel, bring your fishing pole; it was where the Beatles fished from their room when they visited in 1964.

Natives originally used Puget Sound and Elliott Bay to travel, fish, harvest, commute, celebrate, convene, and communicate. They dressed in animal skins, button blankets, and clothes they had made of pounded and woven cedar. When white settlers arrived, they wore heavy-duty work clothes. Henry Yesler built a pier for his lumber mill; the railroads built piers to export coal from Coal Creek and Black Diamond. No dainty clothes for these workers.

When the steamer *Portland* landed at Schwabacher's Wharf (now Pier 57 with the Great Wheel) on July 28, 1897, the 68 miners on board wore tattered clothes with a million dollars of gold in their pockets. Most of the Alaskan gold rush was supplied out of Seattle, and much of the gold came back into the country across Seattle's piers.

After World War II, the piers focused on fishing and shipping. Visitors wore railroad logos—eight lanes of tracks fed the piers. You could buy fish and crabs and shrimp off almost every pier and hop a freighter back east every few minutes.

Some of the piers now provide offices for lawyers and architects and software engineers. As with much of Seattle, ties and skirts are not required. About 1,500 people work in the Central Waterfront piers today, and another nine million passengers use them to board the biggest ferry fleet in the United States or the Victoria Clipper to Victoria, British Columbia, in Canada.

With the new seawall and tunnel for Highway 99, the waterfront is about to enter another phase of attire: urban park and worldwide destination. Maybe they will wear clothes made of animal skins and woven cedar.

—Bob C. Donegan

Bob C. Donegan manages Ivar's Restaurant, which celebrated its 76th anniversary in August 2014. Donegan operates restaurants throughout Washington State. He is an active leader within the local business community along Seattle's waterfront.

ELECTED OFFICIAL

It is not often that a city has a chance to "remake" itself. Seattle has had two opportunities to do so. The first was in 1889 after the Great Fire. The 2001 Nisqually earthquake was the catalyst for Seattle's second chance to remake her waterfront. I have the honor to represent the citizens of Seattle as a city council member for this once-in-a-century opportunity to recreate Seattle's waterfront. To my delight, thanks to a dedicated group of civic and elected leaders, we are now creating what our waterfront *will* be. I am committed to bringing people together and finding common ground on the issues that face Seattle and our region, including helping to create the future of our waterfront. The city, state, and federal government have been working together on this incredibly complex set of projects located along Seattle's Central Waterfront for over a decade. Despite the controversies and challenges, in a few years we will stroll along the newly rebuilt Alaskan Way for a totally new experience. I want to share with you my vision of how we all can enjoy Seattle's waterfront:

We can stroll down the new tree-lined Railroad Avenue turned pedestrian/bicycle corridor to the end of King Street on the waterfront. The Olympic Mountains and sparkling clean Puget Sound provide breathtaking views, and we stop by our Seattle Aquarium and show our children and grandchildren what a clean Puget Sound means. The summer concerts have returned in force on the reconstructed Pier 62/63. Nestled between Terminal 46 and the ferry terminal is a new beach where we can reach the sound with ease and put our hands in the water of Elliott Bay. Returning to Alaskan Way, we look east up Yesler toward the pergola; we can see well into the heart of Pioneer Square. The iconic lampposts and historic buildings are fully open to our view, unimpeded by the aged and cracking viaduct. The viaduct is gone and so is the noise from the 110,000 cars and trucks that travel across it each day. At the newly renovated ferry dock, the ferry queue is now covered and has a sustainable green roof on top. Fewer cars create less pollution because Washington State Ferries has a reservation system; many of us can take the foot ferries and leave our cars because transit is now coordinated with the ferry schedule.

The decisions we make today must be made not just for ourselves within the city borders but for our region as a whole—and not just for today but for generations to come.

—Sally Bagshaw

Sally Bagshaw, attorney at law, has served as a member of the Seattle City Council since 2010. She has worked on Seattle's waterfront for over a decade. She serves as the cochair of Seattle's Waterfront Planning Committee and Allied Art's Waterfront for All Committee.

One

THE WHULGE

Giant mammoths roamed the Salish Sea shores 22,000 years ago, and beginning 16,000 years ago, glaciers extending southward from the Arctic covered Seattle's shorelines with ice nearly one mile thick. As the glaciers slowly began to retreat northward as the climate changed, they scoured the land and carved out deep north-south troughs, which gradually filled with water. The resulting lakes, streams, wetlands, Puget Sound, and the hills, foothills, and mountain ranges are glacial remnants. Native creation stories tell of chaotic change—frigid cold, shifting earth, bidirectional rivers, earthquakes, and volcanoes—until Dookweebathl ("the Changer") brought order to the land.

For nearly 10,000 years, the native people who occupied the forested shorelines knew this saltwater region as the Whulge. Seattle's waterfront originally included a large tidally influenced estuarine area to the south, an island (*Djidjila'letch*, or Pioneer Square), narrow rocky beaches, mudflats, and steep clay banks covered by temperate forests. The forest, marine, estuarine, and tidal ecosystems were teeming with aquatic and terrestrial life that depended on these unique environmental conditions to thrive, creating an interconnected food chain. Cedar trees provided fuel, clothing, shelter, and transportation. The natives cut down giant western red cedar trees and carved them into canoes and paddles for transportation. They used cedar bark to make waterproof clothing, hats, and baskets; they used cedar planks in the construction of longhouses that sheltered several families in permanent villages. Temporary villages dotted the shoreline during the spring and fall fish runs.

The people who called this area home identified themselves as *Dkh'Dus Absch* (Duwamish), meaning "People of the Inside," and *d'suq'wub* (Suquamish), meaning "People of the Clear Salt Water," along with several other Coast Salish Tribes who lived in relative peace, harmony, and wealth, with only occasional hostile raids from the Haida and Tlinglit Tribes from the north. The cliffs along the Whulge provided a final resting place for bodies placed in canoes and set off on journeys to the spirit world. The native population depended on the connection between the seasonal rhythm of life, the shoreline, and open water for sustenance, transportation, communication, and trade.

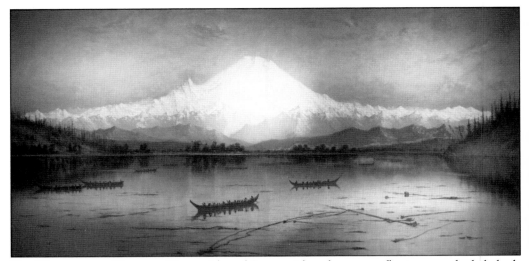

The Whulge and Tahoma. Duwamish and Suquamish cedar canoes float among the kelp beds at high tide in the Whulge (located in what is now the SoDo area of Seattle) in the shadow of Tahoma (Mount Rainier). The pristine waters supported abundant seasonal salmon runs as the fish completed their life cycle—traveling from the freshwater rivers where they hatched, swimming thousands of miles in the ocean, and miraculously returning to the same tributary where they hatched to spawn. This painting reflects the canoe culture that was on the verge of significant change after European contact. (Courtesy WSHS.)

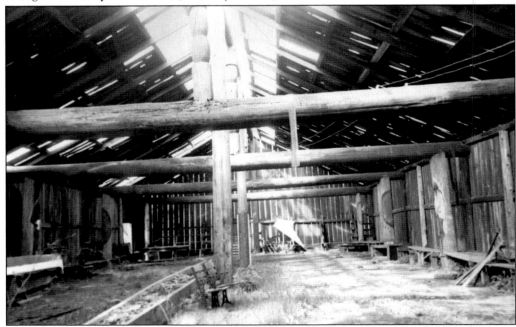

Cedar Longhouses. The Duwamish and Suquamish Indians used materials provided by Mother Nature to build shelters for every season. Cedar longhouses provided shelter throughout the year and served as gathering places during wintertime. The longhouses were located on low-bank shorelines and housed multiple families. This image shows the interior of a longhouse. (Courtesy WSA-AR07809001-ph003097.)

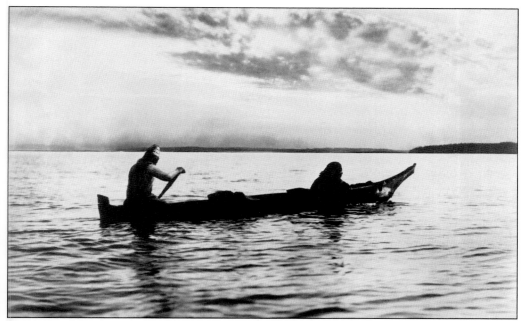

CEDAR CANOES. The native tribes used steam to shape canoes from large cedar trees; they made several kinds of canoes that served different purposes. The tribes used canoes to transport people and goods, travel long distances throughout the Whulge (Salish Sea), fish, gather food, trade, or visit friends and family in other villages. (Courtesy MOHAI-322.)

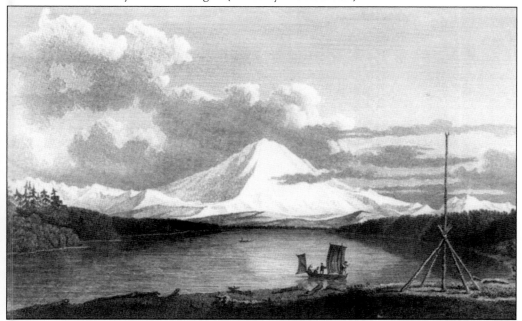

DUCKS AND BIRDS. Waterfowl were abundant on the Whulge. Natural ecosystems provided a year-round habitat for aquatic and terrestrial life and a well-balanced food chain that supported thousands of waterfowl during annual migrations. This sketch from 1792 illustrates the type of poles that were commonly used to net ducks on the Salish Sea. (Courtesy USGS.)

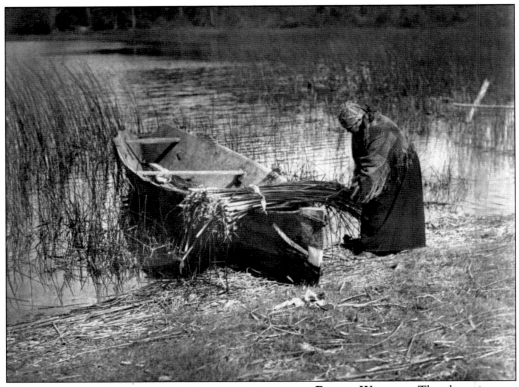

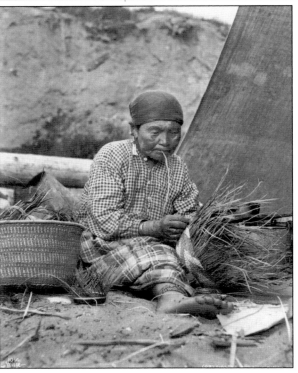

BASKET WEAVING. The above image shows a Salish woman gathering tule (reeds) in a canoe to use in making baskets and mats. In the photograph at left, a Salish woman is weaving a basket of split cedar root. The Salish people made baskets from natural materials such as bark, roots, and grasses, which were coiled or twined. They used baskets to store food supplies such as berries, camas roots, dried fish, and other materials. They also used baskets for cooking, carrying water, or gathering products from the shore such as clams, fish, and seaweed. (Above, courtesy MOHAI-18850-315; left, courtesy MOHAI-88.33.115.)

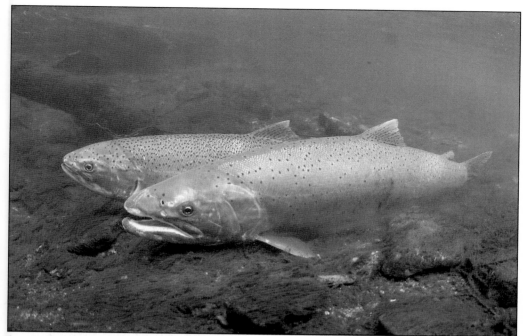

SALMON (ABOVE) AND ORCA (BELOW). All things are connected. The pristine water and habitat in the Whulge (Salish Sea) provided ample habitat for a thriving population of multiple breeds of salmon and several pods of orcas that visited the Whulge each year while migrating between their winter and summer homes. Fully functioning habitats provided all the elements necessary for the food chain to sustain healthy populations of plants, fish, birds, and mammals. (Above, courtesy USFWS; below, courtesy NMFS.)

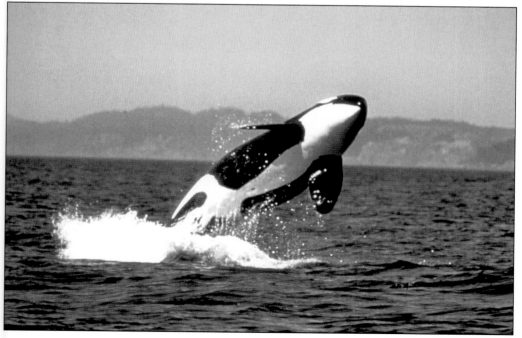

EELGRASS AND KELP BEDS. Eelgrass and kelp beds are considered some of the most productive and biologically diverse ecosystems on the planet. Eelgrass and kelp beds/forests form a unique three-dimensional habitat for marine organisms and serve as the fundamental basis of the food web. They provide a refuge and feeding ground for many animals and are particularly valuable as a nursery habitat. They connect coastal food webs to offshore ecosystems, prevent erosion, stabilize shorelines, and improve water quality by filtering pollutants. In Elliott Bay, these beds were abundant and healthy during the period before white settlers arrived. (Left, courtesy USFWS; below, courtesy NMFS.)

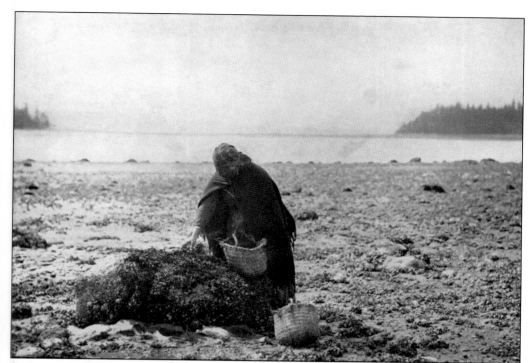

SHELLFISH AND FOWL. When the tide was low, natives—usually women—gathered shellfish (mussels, clams, and oysters) in baskets. The shellfish were eaten fresh or preserved by smoking for use as a primary food source in the wintertime; the Salish also used the shellfish to trade with inland tribes during annual treks to the Columbia River. Waterfowl also provided an abundant food source. (Above, courtesy MOHAI; right, courtesy USFWS.)

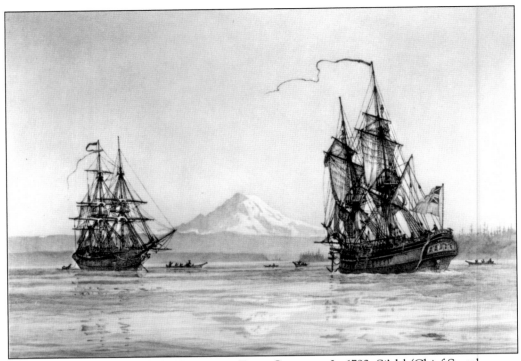

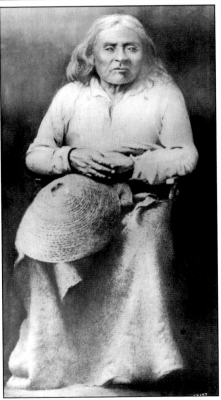

FIRST CONTACT. In 1792, Si'ahl (Chief Seattle, pictured at left) was a young boy when he and his father saw the *Discovery*, captained by George Vancouver, off the shores of what is now Bainbridge Island in Puget Sound (Salish Sea). This is considered the first contact with Europeans and a significant milestone in the history of the Suquamish and Duwamish Tribes, as their lifestyle would be significantly impacted by the introduction of European culture. (Above, courtesy BIHS; left, courtesy SPL-14733.)

Two

PIONEER DAYS

In 1792, Si'ahl (Chief Seattle), a 10-year-old boy from *Dkh'Dus Absch* (the Duwamish Tribe), saw the first Europeans to visit the area when Capt. George Vancouver entered the Whulge in search of the Northwest Passage. Elliott Bay was named in 1841 by George Sinclair, a surveyor on the first US Exploring Expedition into Puget Sound, which was led by Charles Wilkes. The first nonnative people to settle in the Seattle area arrived in the early 1850s. In 1852, Si'ahl befriended Doc Maynard in Olympia, taking him in his canoe and showing him *Djidjila'letch* ("Little Crossing Over Place"), suggesting it would be a good place to establish a home. At nearly the same time, Arthur Denny and his party had come to the same conclusion after having suffered the harsh weather conditions on Alki the previous year.

Maynard, Denny, and Carson Boren platted the land and named it Seattle in honor of Si'ahl. Boren and Maynard soon convinced Henry Yesler to choose Seattle as the place to build the first steam-powered lumber mill in the Puget Sound. The historic shorelines began to change almost immediately as the little village established itself and grew. Yesler built a pier so that vessels could dock and receive/export the lumber and other commodities that would eventually make him one of the wealthiest men in the region.

As the population grew, so did the industries, and the transformation of the shorelines accelerated. Gulches were filled in as the hilly topography was logged. By 1870, Seattle had created a log seawall to keep the fill in place and the sea out—most of the time. While low-elevation shorelines made it easy to access the water, they were often inundated with rain, tidewater, and drainage—a chronic problem with which Seattle still struggles. Wildlife was still abundant in the water. The bay was now not only filled with canoes but also with sailing ships and steam-powered side-wheeler vessels that crossed the body of water, providing transportation and commerce.

By the late 1870s, Seattle had grown to become the largest port north of San Francisco.

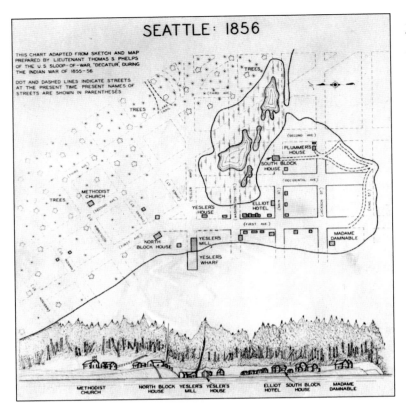

SEATTLE: 1856

THIS CHART ADAPTED FROM SKETCH AND MAP PREPARED BY LIEUTENANT THOMAS S. PHELPS OF THE U.S. SLOOP-OF-WAR "DECATUR" DURING THE INDIAN WAR OF 1855-56

DOT AND DASHED LINES INDICATE STREETS AT THE PRESENT TIME. PRESENT NAMES OF STREETS ARE SHOWN IN PARENTHESES

SEATTLE, 1856. This map shows the original shoreline shortly after the first nonnative people settled in Pioneer Square. Yesler's Mill was near the current location of the Pioneer Square Best Western Hotel. Yesler's Wharf extended several hundred feet into Puget Sound and would have passed under today's Alaskan Way Viaduct. Estuarine tidal flats were located to the south and east of Merchants Café and to the south of First Avenue and King Street. (Courtesy MOHAI-6211.)

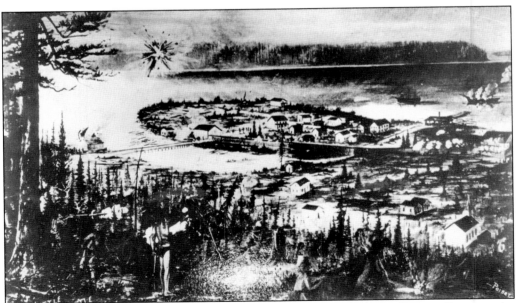

1856 SHORELINE. This sketch, from the viewpoint of Fourth and Cherry Streets, illustrates the shoreline as it appeared more than 150 years ago. The water would have been more than 10 feet deep at high tide in the current locations of the Seahawks and Mariners stadiums. (Courtesy SPL.)

20

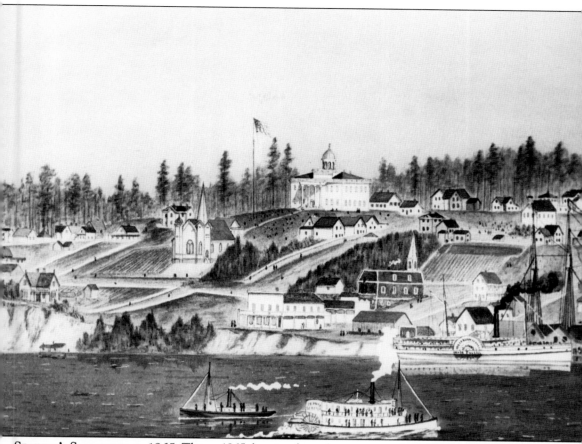

SEATTLE'S SHORELINE, C. 1865. This c. 1865 drawing from the vantage point of Elliott Bay clearly shows the original shoreline in the vicinity of Front Street (now First Avenue) and Pike Street at high tide. Trees are visible along the hill crests, as well as patches in the gullies and along the shoreline. Steep clay banks are also clearly visible. (Courtesy UWSC-SEA1386.)

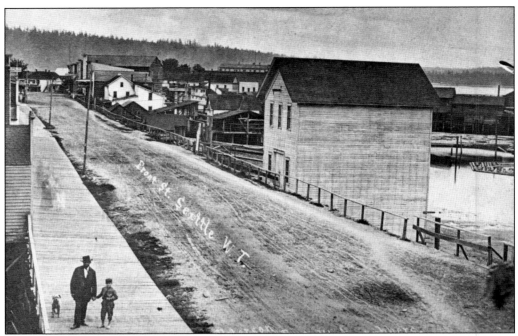

FRONT STREET. The original shoreline had already been modified and fortified by 1860. Access to the water was difficult once development had begun. The wooden sidewalk on the landward side of Front Street (now First Avenue) helped pedestrians avoid the often muddy road and followed the shoreline located to the west of Front Street. The sights, sounds, and smells of Seattle's waterfront had changed from the more natural environment that existed in the 1850s. (Courtesy SPL.)

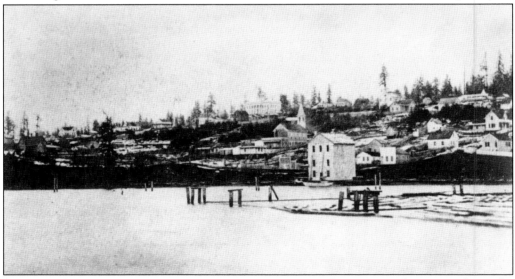

SEATTLE'S SHORELINE, LOOKING NORTHEAST FROM ELLIOTT BAY, 1870. This image shows the waterfront between Columbia and University Streets. The large white building near the top of the hill (now the location of the Olympic Hotel) is the Territorial University (now University of Washington), established in 1861. Trees, vegetation, dirt, and mud are prevalent in this photograph taken at high tide. (Courtesy SPL-5121.)

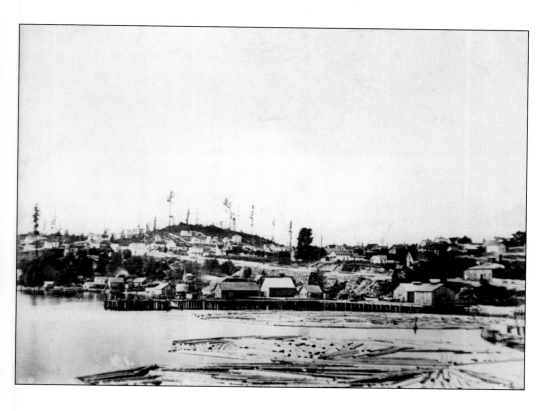

SEATTLE'S SHORELINE, 1878. The above image was taken in 1878 from Elliott Bay, looking northeast from Seneca Street. A few trees are visible at the crest of Denny Hill. (Denny Hill was sluiced away in the 1900s.) Below is a view of Seattle's waterfront looking northeast from near Yesler's dock. Front Street (now First Avenue) runs parallel to the waterfront. Harvested logs float in the water awaiting export or milling at Yesler's Mill. There are steep drop-offs from the dirt street to the buildings on wooden piers along the shoreline. Access to the shoreline was difficult from the upland side. One regrade (leveling hills and filling ravines) had been completed by the time the below photograph was taken in 1878. (Above, courtesy SPL_shp_5125; below, courtesy WSHS.)

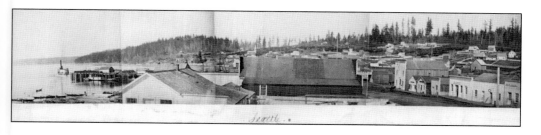

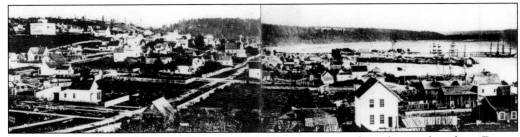

SEATTLE'S SHORELINE, LOOKING SOUTH, 1878. This image may have been taken from Denny Hill. Development of the city extended to Fourth Avenue. The body of water to the south contains the estuarine tidal flats, which, depending on the tide, alternate between mudflats and 20-plus feet of salt water; this area is now home to industrial development and sports arenas. The hillsides surrounding the tidal flats are old-growth forests. Pioneer Square still maintains its shape as a peninsula. Yesler's Wharf has several sailing ships alongside the dock. (Courtesy UWSC-SEA3497.)

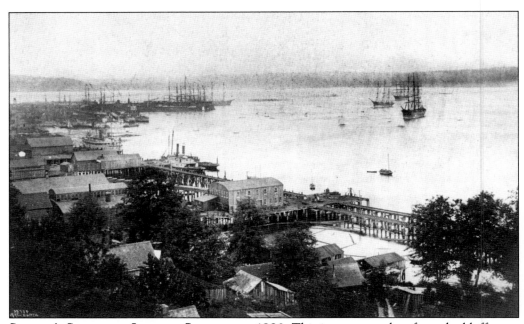

SEATTLE'S SHORELINE, LOOKING SOUTHWEST, 1880. This image was taken from the bluffs near First Avenue and Union Street. Seattle's waterfront has several piers, and railroad tracks known as the Ram's Horn (named for their shape) parallel the bustling shoreline of Elliott Bay. If a person wished to reach the water or beach, it would be difficult for them to access to the waterfront area from the land. (Courtesy UWSC-CUR1245.)

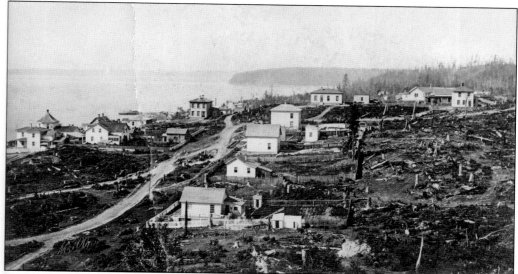

SEATTLE'S SHORELINE, LOOKING NORTHWEST, 1882. This photograph was taken from Third Avenue and Virginia Street. Due to limited flat terrain, developers were required to harvest steep slopes to make land available for homes. This image shows stumps—the remains from the harvest of old-growth timber that once covered Seattle—among newly built wood homes, along with a set of meandering roads that look more like trails. The wharf in the distance belonged to G.L. Manning. (Courtesy SPL_SHP_5161.)

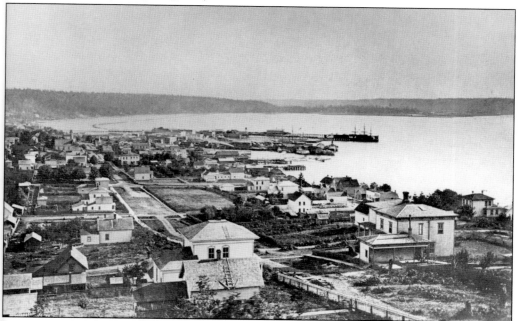

SEATTLE'S SHORELINE, 1887. In this image looking south from Denny Hill, the SoDo area is still a marsh south of Pioneer Square. The first elevated railroad trestles had been constructed in the estuarine tidal flats to assist with export of the many natural resources, such as coal and timber, that were being extracted and exported. With a population of 12,000, Seattle had finally surpassed Walla Walla to become the largest town in Washington. (Courtesy SPL-SEA-3497.)

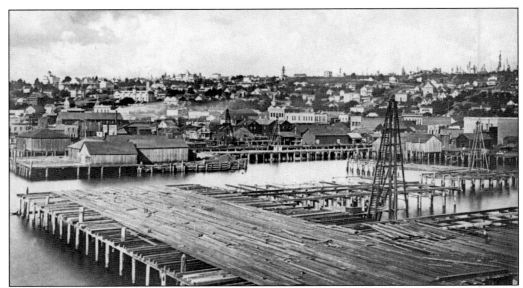

WATERFRONT WHARFS, 1882. Seattle's economy thrived thanks to the shipping of the abundant natural resources available to be extracted and sold across the global market. However, the pristine waters of Elliott Bay had been negatively impacted in a variety of ways since Seattle's Pioneer Square had been settled. The above image illustrates the area near Madison Street and the overwater placement of piers and buildings. Covering the water in such a manner significantly alters the amount of sunlight that can enter the water column, which impacts aquatic plants and animals that sustain many critical food chains for fish, mammals, and people. The construction had a particularly large impact on the environment needed for the migration of juvenile salmon from their freshwater spawning areas as they attempt to begin their journeys to the ocean, as the resulting shadows provide ideal conditions for predators of the juvenile salmon. Below is the waterfront near Yesler Avenue. (Above, courtesy SPL_SHP_7319; below, courtesy MOHAI-SHS3506.)

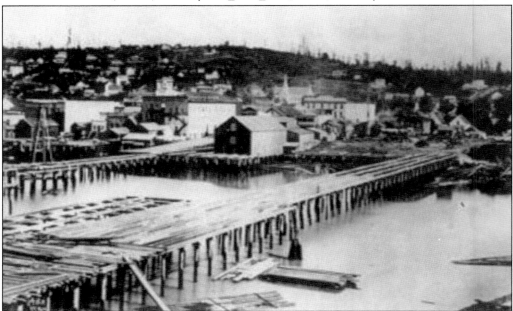

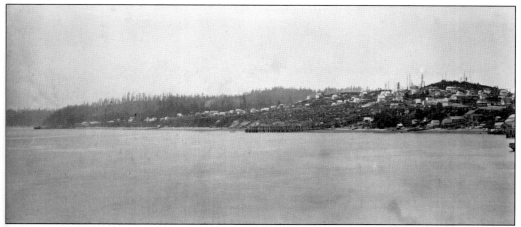

PANORAMIC WATERFRONT, 1880. Old-growth forest is visible on Denny Hill to the north of this panoramic view of Seattle. Denny Hill is on the right, and Queen Anne Hill is in the distance. The shoreline is a combination of high-bank bluffs and low-bank beaches. Housing is located on both the beaches and the upper banks. It appears the tide is out in this view from Elliott Bay. (Courtesy UWSC-HES306.)

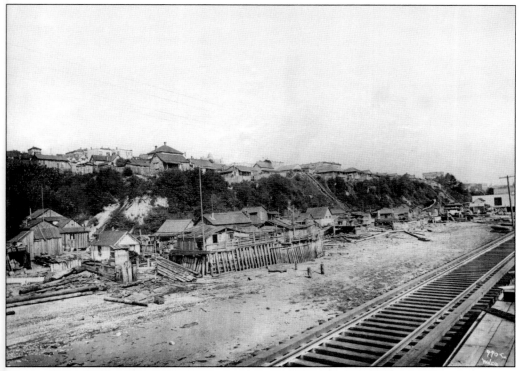

SEATTLE WATERFRONT AT PIKE STREET, 1900. By 1900, numerous railroad tracks had been laid along the shoreline. This image shows the shanty houses on the beach below the banks of First Avenue and Pike Street. The buildings on the bluff include Hotel York, which was demolished and replaced with Pike Place Market in 1910. Today, Western Avenue goes up the hill at University Street (roughly where the shanties are shown on the beach in this image). This is also the present-day location of the Alaskan Way Viaduct below Pike Street. (Courtesy MOHAI-SHS-13091.)

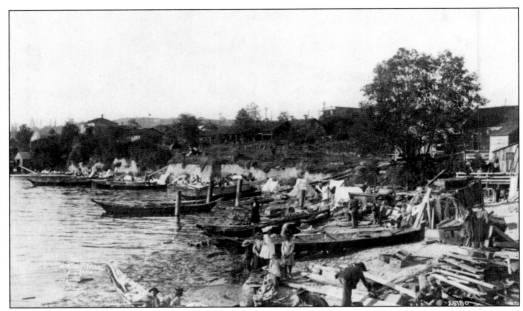

INDIAN CAMPS, 1880s. Despite the fact that an 1865 ordinance passed by the Seattle city council banned Native Americans from living within the city limits (their original homeland), several Indian camps were located along Seattle's shoreline, which offered easy beach access and fresh water. The above image was taken at the foot of Vine, Cedar, and Broad Streets. The below image is at Bell Street, which was known as Indian Camp Muck-Muck-Wum. Canoes continued to be the primary source of transportation and, at times, provided shelter. Indians from many tribes traveled to Seattle to trade, work, or socialize. (Above, courtesy SPL_shp_5229; below, courtesy MOHAI-1123.)

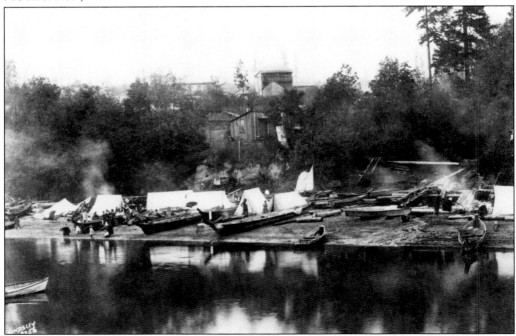

Three

SAILS AND RAILS

Constrained by Puget Sound to the west, Seattle grew to the north, south, and east from its original birthplace in Pioneer Square. As Seattle grew, the waterfront continued to change—significantly. The physical location of the shoreline moved out as fill from sawmills and dirt from regraded hills were deposited to transform tidelands into uplands. The look of the waterfront changed, as did its access and use. Despite Seattle's bitter disappointment that, in 1873, the Northern Pacific Railway chose Tacoma as the western terminus for the first transcontinental railroad to Puget Sound, the city continued its pursuit of the railroad. Seattle boasted a busy port full of industry, commerce, watercraft, and people. By 1881, Seattle had surpassed Walla Walla in population and become the largest city in the Washington Territory.

On June 6, 1889, a small pot of glue that was accidently knocked over caused the Great Fire of 1889, which destroyed a large section of the city's business district and waterfront overnight. The spirit of Seattle turned this challenge into an opportunity. Seattle reinvented herself and realigned her shorelines, and a new waterfront soon emerged. By the 1890s, a web of trestles and piers supported plank roads, rails, docks, and warehouses. Early streetcars, trains, and dirt roads had been added to the transportation network, so Seattle's shoreline became a multimodal hub of activity.

The sensory characteristics of Seattle's waterfront had also changed considerably. Natural shorelines had been covered by Railroad Avenue, which linked water and land to support the bustling waterfront. The tall old-growth trees had been cut for homes, fuel, and export, changing the view of the city from the water and allowing the water to be seen from land. The arrival of gold on the SS *Portland* at Elliott Bay in 1897 served as the catalyst for Seattle's waterfront becoming known as the "Gateway to the Klondike." Seattle's waterfront continued to serve as the "Front Door to the City," while a working waterfront dominated by sails and rails greeted visitors and local travelers as they arrived at Seattle by sea.

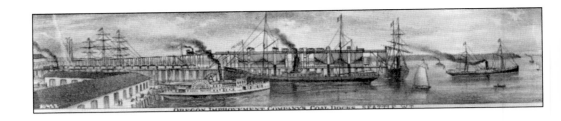

COAL BUNKERS. The Oregon Improvement Company built the company's coal dock in the 1880s. Located near King Street, the coal bunkers served as the key supplier of coal for steamships arriving in Seattle. In 1881, Oregon Improvement Company president Henry Villard purchased a majority of Northern Pacific's common stock and named himself president of that company, too. The above image shows steamships and the Mosquito Fleet (small steamships providing transportation around Puget Sound) arriving at the coal bunkers to refuel. Black plumes emanating from the smokestacks contributed to poor air quality and visual impairment wherever they operated. Elliott Bay often had a layer of black smog, as coal-powered watercraft swarmed to Seattle's waterfront. On the left side of the below image, logs recently harvested from old-growth forests float in Elliott Bay as they await export or milling. (Above, courtesy SPL; below, courtesy MOHA-2202.3.1643.)

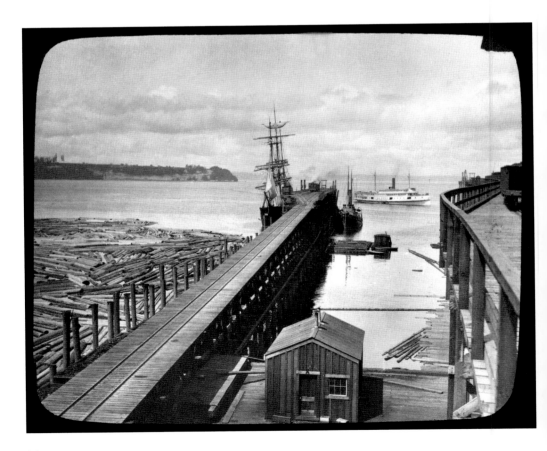

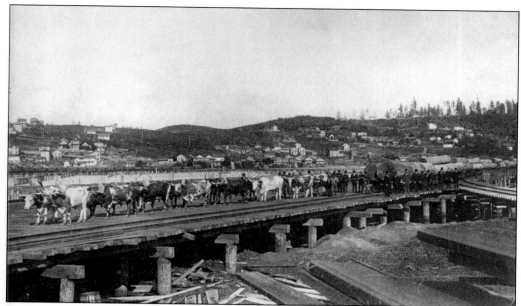

TIMBER! The trees that covered the hills of the Seattle area were hundreds of years old, and harvesting these giant trees was no small feat. Transporting the tall timbers to Seattle's waterfront was an even more difficult task. When feasible, trees were felled and skidded down a road (known as Skid Road or Mill Street) made from logs laid crosswise to Yesler's Mill. As the trees were harvested from farther out, they were either floated to Seattle for export or hauled by oxen along wood-planked piers to awaiting vessels, as shown above in the c. 1860 image. Some of the wood was used locally; however, a large percentage was exported. In the 1882 image below, several wharfs are visible, including the Jackson Street Wharf, City Dock, and Ocean Dock. These photographs illustrate that access to the waterfront has been difficult for over 150 years. (Above, courtesy SPL-shp-5133; below, courtesy SPL-shp-1488.)

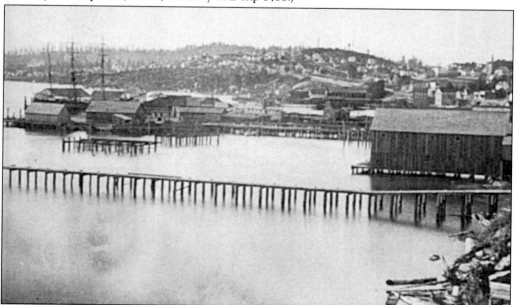

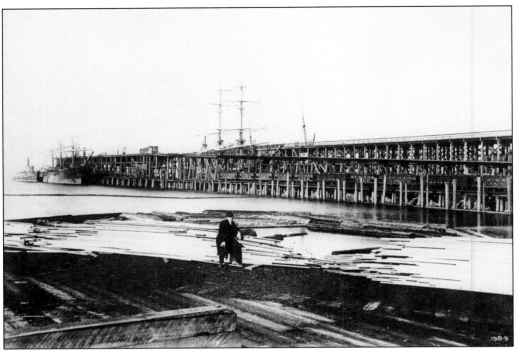

NATURAL RESOURCE EXTRACTION. When the pioneers settled in Seattle, they began to extract natural resources to make money. Almost immediately, ancient forests were harvested and milled for export to San Francisco, the primary market. Coal was extracted from Newcastle, Renton, and other mines as a primary fuel source for the many steamships that plied the waters of Elliott Bay and for San Francisco businesses and homes. In the 1890 image above, Capt. John Williamson poses in front of the Oregon Improvement Company's coal dock. Milled lumber on the dock awaits export. The Columbia and Puget Sound coal bunker trestle (below) was built in 1878 on piers and a wooden platform above the estuarine area behind Pioneer Square (near the current location of the Seahawks stadium). (Above, courtesy SPL_shs_1590; below, courtesy SPL_shs_1448.)

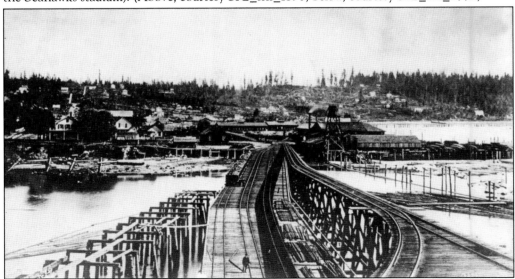

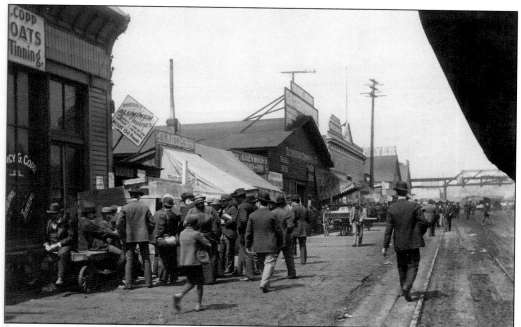

RAILROAD AVENUE, 1898. After the Great Fire of 1889, Seattle rebuilt the city with bricks and stone while simultaneously elevating streets 10 to 30 feet above ground to avoid the drainage problems that had plagued it at its original grade. Rebuilding and elevating the city provided an opportunity to fill the near-shore and extend land out into the original tidelands, and the end result was an elevated platform of wooden docks, piers, and railroads supported by wood pilings. By 1897, when the cry of "Gold!" resounded as the SS *Portland* docked at a slip between Schwabacher Pier and Pike Street Pier along Seattle's waterfront, the transformation of Seattle's natural shoreline to a built urban environment was almost complete. Railroad Avenue bustled with people, merchandise, ships, wagons, and trains as thousands of people thronged to Seattle's waterfront on their way to Alaska—hence the name "Alaskan Way." (Above, courtesy MOHAI-shs2500; below, courtesy SPL_shp_14669.)

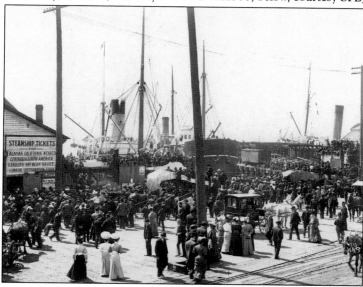

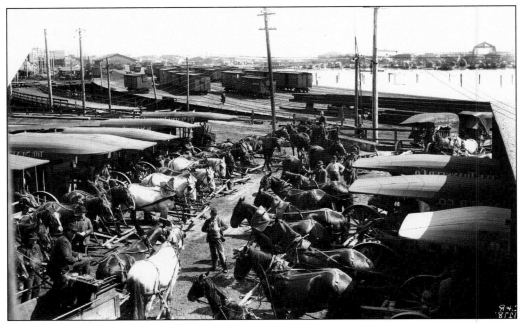

MOVING GOODS. Transporting goods to and from Seattle's waterfront docks to warehouses, wholesalers, retailers, and customers (east-west movement) has long been a challenge. The c. 1899 image above shows horse-drawn wagons, which belonged to the Seattle Transfer Company, lining Railroad Avenue. Behind the wagons, several rows of freight cars are visible on Railroad Avenue, with Elliott Bay in the background. Below, a 1911 image of Railroad Avenue illustrates how the railroad companies largely controlled the use of this precious 120-foot right-of-way. At least eight railroad tracks were built along Seattle's waterfront as companies competed to provide service to support the growth of Seattle's port. The congestion was horrific, chaotic, and dangerous; any pedestrian who ventured onto Railroad Avenue was at high risk of injury or death. (Above, courtesy WSHS-1943.42.1279; below, courtesy MOHAI-1983.10.6713.)

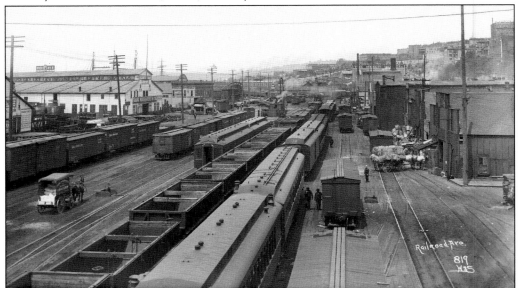

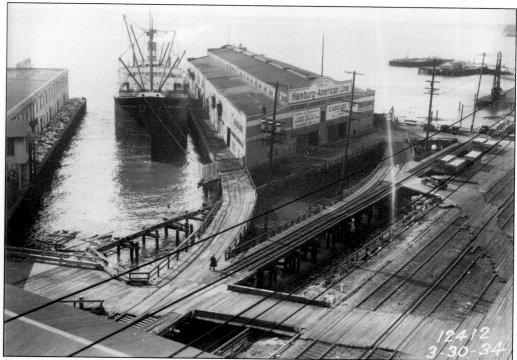

THE DANGERS OF RAILROAD AVENUE, 1934. These 1934 images of Railroad Avenue illustrate the focus on moving goods from ships to rail for final or intermediate destinations. More than eight sets of railroad tracks are visible above, along with precarious openings in the wooden platforms. City records are full of accidents: injuries and deaths of people and horses, as well as vehicles falling into the bay or being hit by trains. People carried out business on the waterfront—retail stores, bars, and restaurants dotted the piers and Western Avenue—but it was not easily accessible or used by people for recreation, leisure, or daily routines. It was a working waterfront, and it was dangerous due to trains and the gaps in planks that could drop an unaware pedestrian or driver into the bay. (Above, courtesy SMA-8785-12412; below, courtesy SMA-8739-12367.)

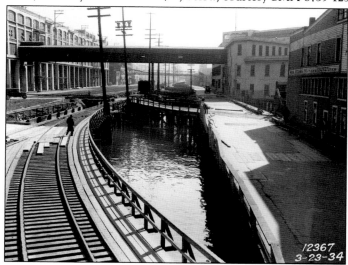

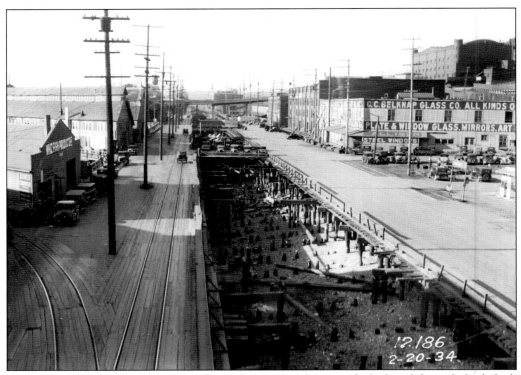

RAILROAD AVENUE, 1934. Interestingly, in 1934, Railroad Avenue lacked a solid wood-plank dock with multiple sets of railroad tracks. The above image, looking north from Pike Street, and the below image, looking south from Lenora on Railroad Avenue, show a large open channel between the wharf/docks located to the west and the warehouses located to the east of Railroad Avenue. The depth of water in the open channel depended on the tide; the beach is visible in the above image, while water fills the channel in the below photograph. There were retail establishments on the waterfront throughout this era. Seattle's residents traveled to the waterfront via several pedestrian overpasses, as the ground level was primarily industrial and monopolized by the railroads. (Above, courtesy SMA-8552; below, courtesy SMA-8924.)

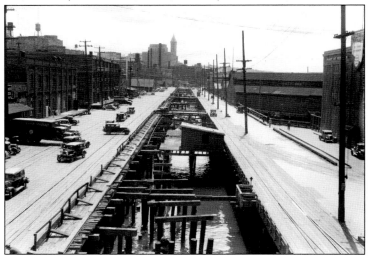

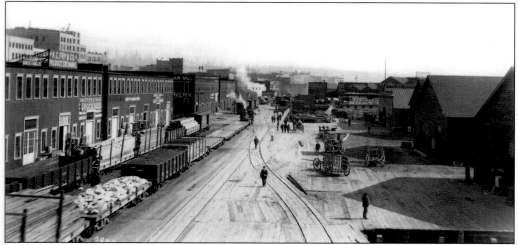

RAILROAD AVENUE, 1890s (ABOVE) VS. 1930s (BELOW). With the exception of horse-drawn wagons in the above image and cars in the below image, the look and feel of Railroad Avenue appears unchanged. The wooden platform supports multiple railroad tracks and trains between the wharfs to the west and warehouses to the east. The few people—all males—shown in both images illustrate the fact that Railroad Avenue was not pedestrian-friendly; in fact, it was downright dangerous. Women and children would have ventured to the waterfront primarily to catch local steamers and ocean liners. The above image looks south on Railroad Avenue, while the below image looks north. (Above, courtesy TPL-33197; below, courtesy SMA-4072.)

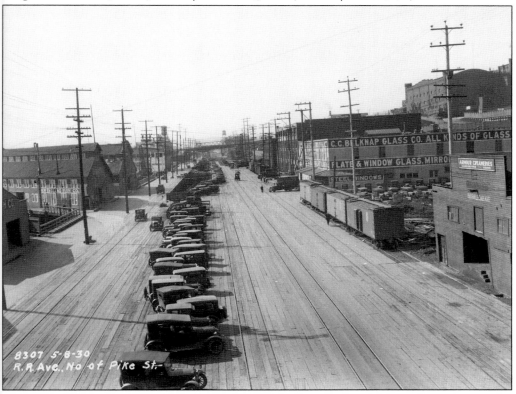

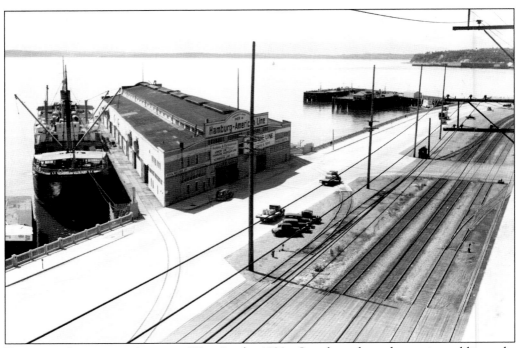

RAILROAD AVENUE TO ALASKAN WAY. In the 1930s, Seattle undertook a major public works project to build the seawall and an improved roadway. Both of these photographs were taken on Railroad Avenue from the American Can Company, located between Clay and Vine Streets. The above image looks north and the below image looks south in 1936. The seawall has been completed, along with a new roadway for cars, and Railroad Avenue has been renamed Alaskan Way. The multiple tracks along the railroad right-of-way are visible to the east of the new road. Improved sidewalks were installed on the westward waterside of the road. Note the few cars on the roadway in both images—perhaps a function of the time of day the picture was taken. At other times, even in 1936, Alaskan Way was filled with cars. Also note the dark plume of air pollution to the south in the below image. (Above, courtesy SMA-10493-13975; below, courtesy SMA-10496-13978.)

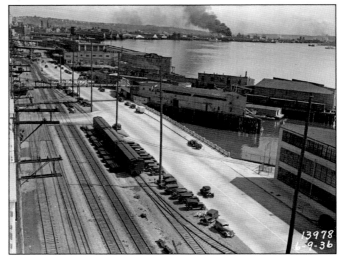

Four

ENVIRONMENTAL
LANDSCAPE CHANGE

The daily rhythm of the rise and fall of the tide creates a unique estuarine environment. The Duwamish and Suquamish Indians understood and respected the natural resources that Mother Earth provided. The Suquamish Tribal Museum states: "We are born of these ancient shores, where the water touches the land, and where the gifts of opportunity are revealed with every changing tide . . . We have a connection to this earth, this water." Martha George, a Suquamish elder, states that elders taught younger generations to "respect the earth." She goes on to say, "They took what they needed, and that's all. There was nothing wasted." The land and shoreline provided food, shelter, transportation, medicine, clothing, and material resources.

This framework of sustainability between people, the environment, and natural resources began to change as Seattle was settled. Significant extraction of timber, fish, coal, and other natural resources immediately began as the nonnative population created its own economic engine of commerce. Virgin forests were harvested, and land was cleared to accommodate exports, housing, and roads, resulting in irreversible changes to the shoreline that impacted the delicate balance between flora, fauna, and people.

As time passed, city leaders implemented more aggressive measures to modify the natural environment. Engineers built seawalls that kept water out while simultaneously supporting the city. Hillsides were washed into Elliott Bay, forever changing the look, feel, and use of the landscape. The regrading of Seattle's many hills to level the terrain resulted in thousands of acres of pristine aquatic lands being filled in and forever destroyed the ecological functionality of the system. Today, many Seattleites pride themselves on living in the "Emerald City," a progressive metropolis of environmental integrity and sustainability. Ironically, Seattle's history of negative environmental impact is anything but "green."

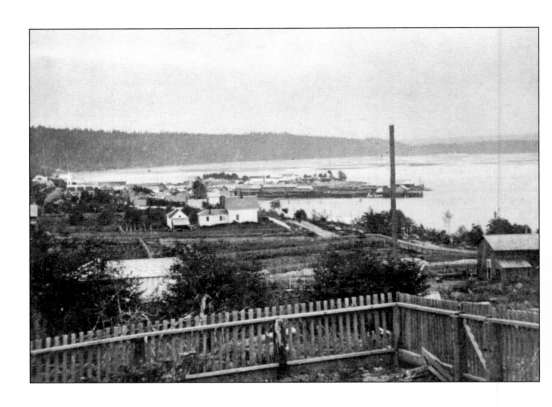

INTERTIDAL LANDS. The once pristine marine waters and estuarine intertidal lands located south of Pioneer Square—which provided abundant habitat for shellfish, juvenile salmon, kelp, and eel grass (see page 12)—had already experienced significant change by the mid-1870s, as shown in the above image. While the original swampy aroma of tidelands and a marine environment remained in the air, new odors arose with the dumping of industrial, commercial, and domesticated waste into the water and onto the shorelines. The original pristine water quality and near-shore habitat was gradually being degraded, and the new sights and smells, which greeted new visitors and residents alike, were called "progress." (Above, courtesy SPL-shp-7281; below, courtesy SPL-shp-15130.)

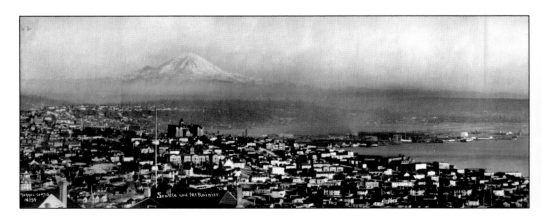

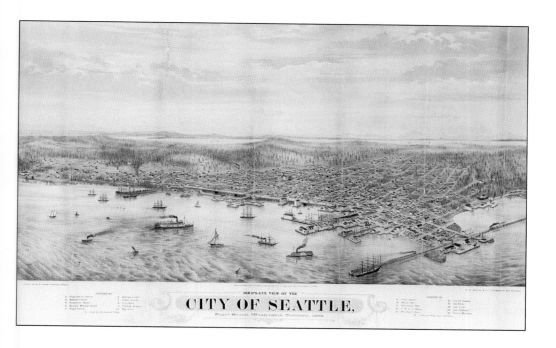

BIRD'S-EYE VIEWS, 1878 (ABOVE) AND 1904 (BELOW). The sights, sounds, and smells of Seattle's waterfront changed considerably from the initial environmental baseline of the first 25 to 50 years of nonnative settlement. Wildlife was still abundant in the water, but in addition to the traditional canoes, the bay was filled with sailing ships and paddle steamers used for transportation and commerce. Noises and whistles from the mills and vessels hummed the music of progress. The sights included new styles of homes, fewer trees, many stumps, dirt roads, wooden sidewalks, and several hotels. The aromas of the growing city and her shoreline had not improved with time. Significant filling of the shorelines had taken place on both the central waterfront and the intertidal marshlands to the east and south of Pioneer Square (now the SoDo district). (Both, courtesy SPL.)

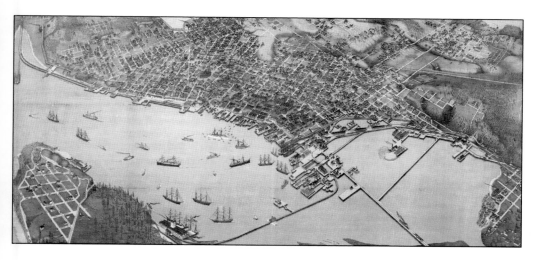

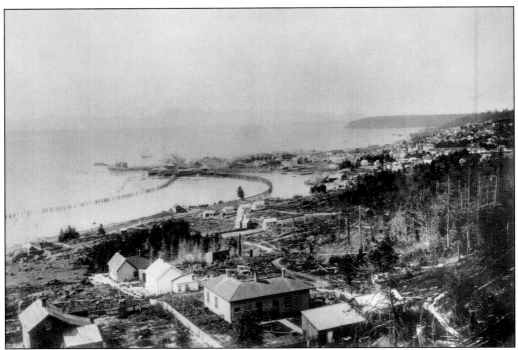

FILLING TIDELANDS WEST OF BEACON HILL. An 1880s image (above) contrasted with an 1898 image (below) demonstrates the gradual yet significant filling of the estuarine shorelines east and south of Pioneer Square, which today comprise the Port of Seattle Terminals and SoDo District. Ancient forests were harvested and the land was cleared, resulting in an exponential increase of soil erosion and sediment delivery to streams, rivers, and marine waters and negatively impacting habitat and the food web. The economic development reflected the environmental degradation. (Above, courtesy WSHS-1943.42.17047; below, courtesy SPL-shs-23050.)

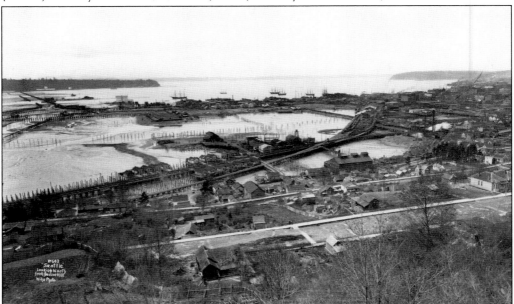

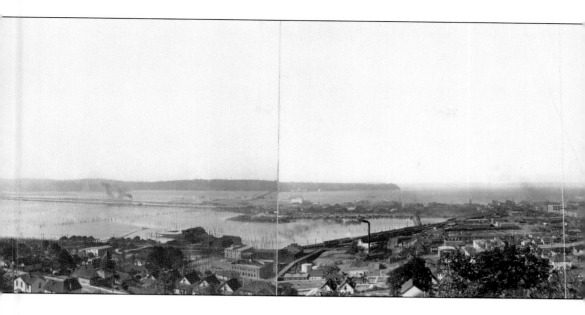

RAILROAD TRESTLES AND INTERTIDAL LANDS. By the 1880s, piles had been driven into the estuarine water and the tidelands located south and east of Pioneer Square (now the SoDo district) to support several elevated railroad trestles used to haul coal, timber, and other products to Yesler's Wharf for commerce. The gradual filling of the tidelands would have a cumulative effect over time, negatively impacting the aquatic habitat for many species. The fishery and shellfish in the area were devastated by water pollution, sediment delivery and the loss of habitat that previously supported fish and a chain of aquatic plant life that depended on a delicate balance in order to be a fully-functioning ecosystem. (Above, courtesy SPL_shp_40048_1; below, courtesy SPL-shs_22783.)

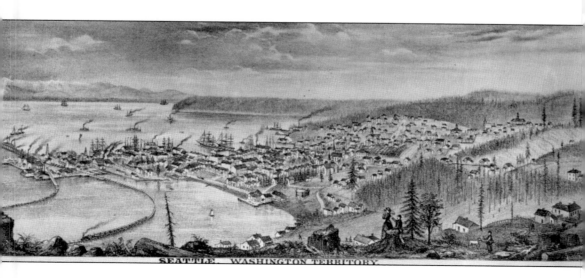

SEATTLE, WASHINGTON TERRITORY.

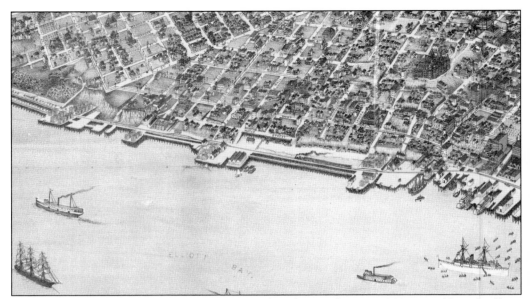

1891 MAP—PIKE STREET TO GRANT STREET. This close-up from an 1891 map of Seattle allows a closer look at both the railroad trestle that parallels the original shoreline and the shoreline itself benchmarked against east-west streets. Wood shanty houses stretch from Bell Street south to Pike Street. The natural ravine at the end of Bell Street is visible, as are the banks from Bell Street south to Pike Street. (Courtesy SPL.)

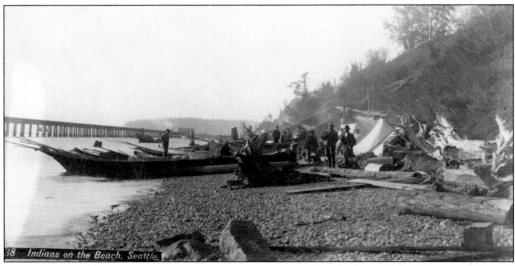

BA'QBAQWAB. This Native American encampment, located at the base of the bluff on the beach near a ravine at the foot of Bell Street, was where many of the local Duwamish Indians moved after the 1865 city ordinance that expelled the Native Americans from the city limits of Seattle. Many of the Duwamish who made "Djidjila'letch" (Pioneer Square) their traditional winter home moved to this site known as Ba'qbaqwab. By the end of the 1890s, most of the Native American encampments located along the shorelines were gone. (Courtesy WSHS-1979.45.30.)

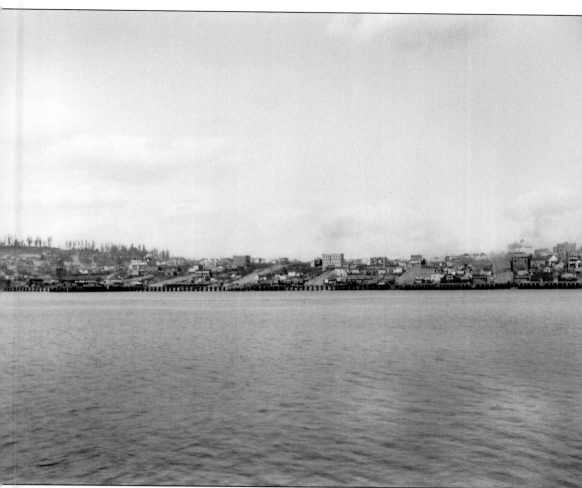

LOOKING WEST TOWARDS DENNY HILL. The railroad trestle parallels the beach below Denny Hill in this c. 1900 photograph. A few remaining trees that had not yet been logged are visible on Denny Hill. Loss of forest habitat significantly increased soil erosion and sediment delivery to streams and marine waters, impacting the habitat. Significant environmental change has occurred in this area over the past 130 years, including the regrading of Denny Hill, filling in the shoreline and extending it out several blocks, urbanization, and the construction of major transportation corridors such as the Alaskan Way Viaduct and Battery Street Tunnel. (Courtesy TPL.)

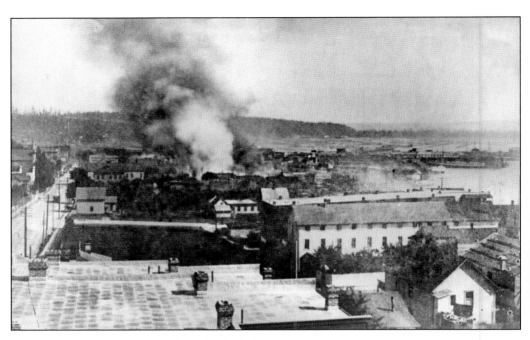

GREAT FIRE OF 1889. A pot of hot glue boiled over in a carpenter's shop on June 6, 1889, ignited turpentine-soaked wood shavings covering the floor, and burst into flames. The flustered apprentice threw water on the fiery pile, which inflamed the situation. Low tide (which eliminated the ability to use salt water to fight the fire), short fire hoses, wooden structures, strong wind, and a lack of water pressure resulted in Seattle's waterfront turning to ashes in a just under 12 hours. Miraculously, no lives were lost. This misfortune set the stage for tremendous change for Seattle's waterfront. (Above, courtesy SPL-1543; below, courtesy SPL.)

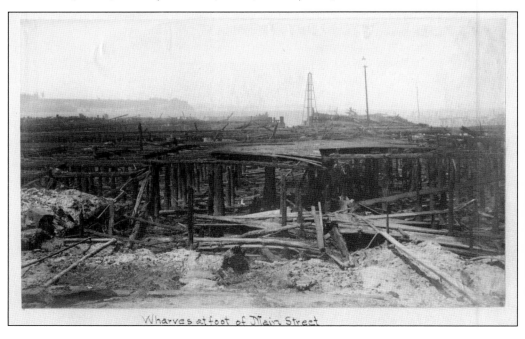

Wharves at foot of Main Street

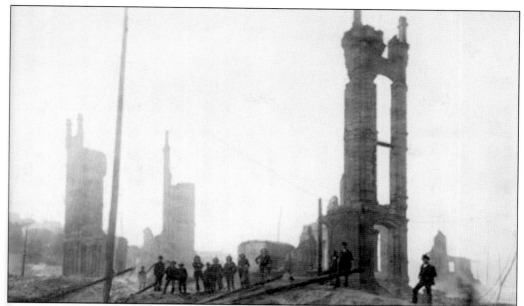

SEATTLE'S WATERFRONT AFTER THE 1889 FIRE. All mills, wharfs, and buildings—from Union Street to Jackson Street, with the exception of Schwabacher Dock and Warehouse No. 1 (located near the foot of Union Street)—were destroyed by the conflagration. This devastating fire provided the catalyst for Seattle to elevate roads (resulting in Underground Seattle), create a new street grid, establish a fire department, develop a new water system, and replumb the city. Seattle's shorelines proved to be the most convenient and expedient location to dispose of the remains of the charred city during the restoration process. Not only was the elevation of the city increased, the shoreline was eventually extended up to 300 feet into the bay in places, changing aquatic lands to uplands. An unintended consequence of Seattle's Great Fire of 1889 was the significant change to the shoreline and aquatic habitat. (Above, courtesy SPL-1387; below, courtesy SPL-1544.)

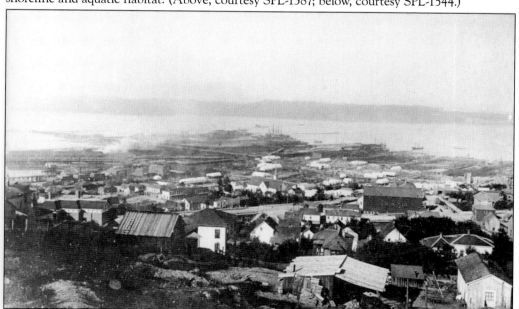

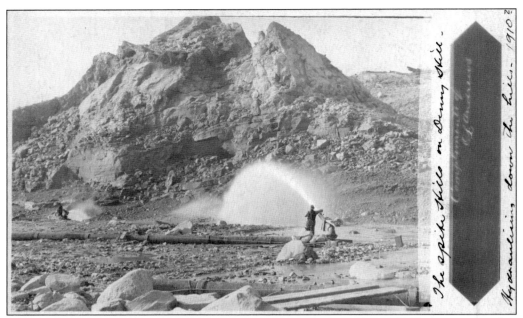

DENNY HILL REGRADE CHANGES SEATTLE'S SHORELINE. Engineer Reginald Thomson arrived in Seattle in 1881 and quickly noted the hilly topography. He envisioned flatter contours, which he felt could better support economic and population growth, along with basic utilities, including a safe drinking water supply, fire flows, wastewater systems, roads, and electricity. Thomson was soon in a position of power and aggressively acted upon his vision of a flatter Seattle. The city endured multiple decades (the 1890s through the 1920s) of regrades influenced by Thomson. These images show the significant masses of soil being removed by sluicing (pumping water under high pressure) to remove millions of cubic yards/tons of soil from Seattle's hills to Seattle's shorelines, resulting in the loss of the original shoreline and habitat. The new shoreline was located several blocks out into Elliott Bay from the original Front Street (First Avenue). (Above, courtesy SPL-1693; below, courtesy UWSC.)

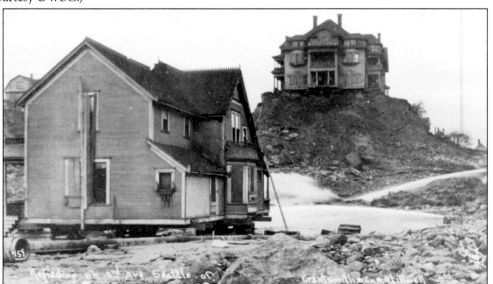

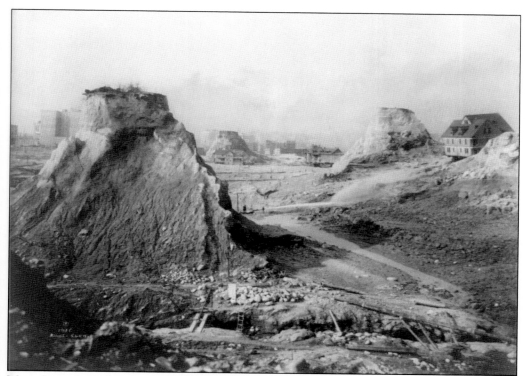

MOVE IT OR LOSE IT.
These 1910 images of the Denny Hill regrade illustrate the massive effects that the regrading projects had on people, the landscape, and the environment. If houses were not removed, they were washed away, along with the soil that would be deposited along Seattle's shoreline and mudflats as fill. While the regrades created niche industries such as house moving, sluicing, hauling, and soil dumping, many people were not pleased with the projects' impact on their property and lives. (Above, courtesy USLOC; right, courtesy UWSC-WAR0355.)

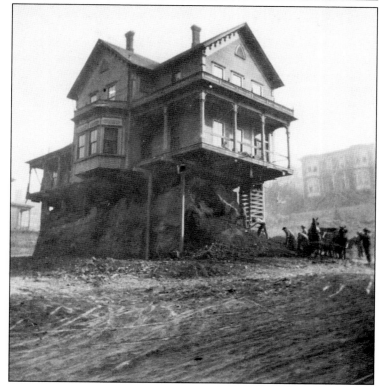

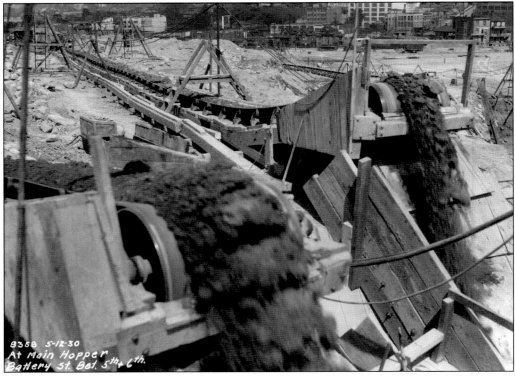

Moving Soil from the Hills to Seattle's Shoreline. Removing Seattle's hills was difficult work. Getting the soil from one location to the ravines and gulches of the shoreline took innovation and tenacity. For more than three decades, Seattle transformed its hills and shorelines by transporting regraded soil via conveyor systems, horses and wagons, steam shovels, pipes, and barges. Millions of cubic yards of soil were deposited in a prime habitat area home to a wide variety of plant and aquatic species. The degradation was significant and permanent. (Above, courtesy UWSC-LEE256; below, courtesy UWSC-LEE081.)

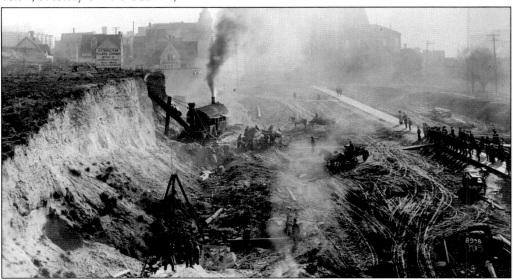

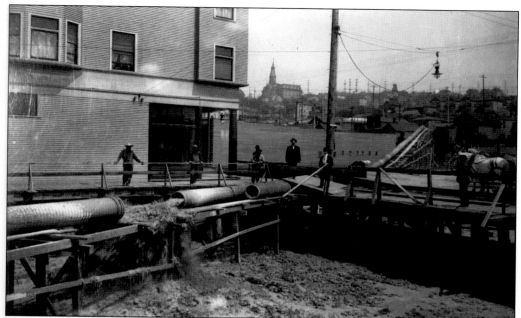

MOVING MUD, PIPES, AND BARGES. A variety of innovative approaches were implemented to convey the muddy slurry to the tidelands throughout the regrading decades. The above image shows pipes transporting slurry from the sluicing efforts to the tidelands to "reclaim" the aquatic lands. The below image shows a barge dumping soil into the bay, which impacts habitat, fisheries, and navigational waterways. Environmental impact statements were not required—they did not yet exist during this time period. Neither public input nor cooperation with other agencies, especially ones with differing opinions, were required or desired. Environmental costs simply were not part of the equation during the construction boom of the early 20th century. The social, environmental, and economic impact of projects like these most likely contributed to the development of laws like the federal National Environmental Policy Act (NEPA) and Washington's State Environmental Policy Act (SEPA). (Above, courtesy UWSC-SEA1215; below, courtesy UWSC-CISOBox1.)

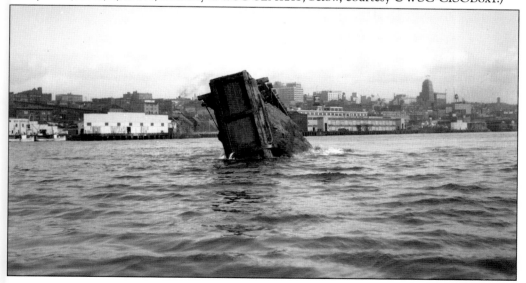

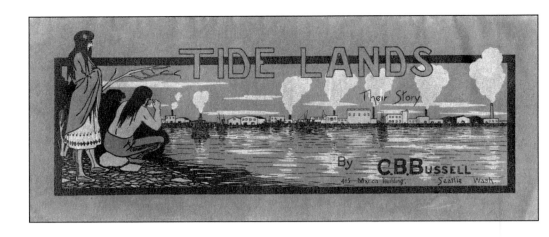

CHANGING TIDELANDS (ABOVE) AND 1904 MAP (BELOW). C.B. Bussel published *Tide Lands: Their Story* (above), which focuses on the benefits provided by Seattle's reclaimed lands. The filling of tidelands south and east of Pioneer Square (today's SoDo district) originally provided a rich ecosystem for plants and animals, a major migration route for salmon returning to spawn in the Duwamish River, and an excellent habitat for juvenile salmon beginning their epic journey to the ocean at the beginning of their life cycle. This area was also a common hunting, fishing, and gathering place for the Duwamish, Suquamish, and Muckleshoot Tribes. The scale of change is clearly apparent in the 1904 bird's-eye view of Seattle (below). The filling of the tidelands and the discharge of polluted water, toxic waste, solid waste, and air pollution contributed to the permanent loss of the habitat. (Above, courtesy SOL-SAW-187754; below, courtesy SPL.)

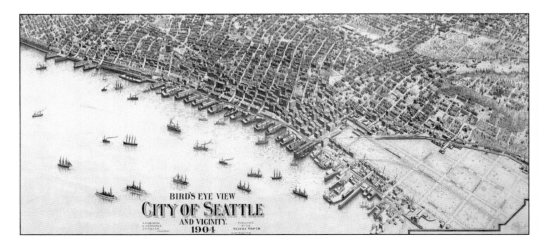

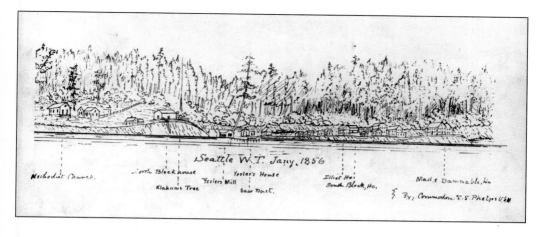

Methodist Church. North Block house Yesler's House Elliot Ho. Made Damnable Ho
Klakuns Tree Yesler Mill South Block Ho.
Saw Dust. By; Commodore T. S. Phelps USN
Seattle W. T. Jany. 1856

SHORELINE, 1856 (ABOVE) AND 1865 (BELOW). The look and feel of Seattle's shoreline has changed over time, with changes that have been both gradual and rapid. The 1856 sketch shows the original shoreline that the first settlers saw when they began to set up a town in Pioneer Square (*Djidjila'letch*). Crowns of old-growth forest dominate the skyline. By 1865, the forests had been cleared on much of the western-facing hillsides. Dirt roads and paths lead to buildings perched on the clay banks located in the vicinity of Pike Street. With the exception of the tree-covered ravine on the left, access to the shoreline from land was difficult along the east-west corridors. Marine vessels (including canoes) continued to be the primary and easiest mode of transportation to and from the shoreline. (Above, courtesy SPL-1619; below, courtesy UWSC-SEA-1386.)

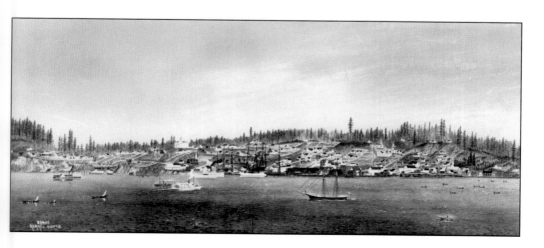

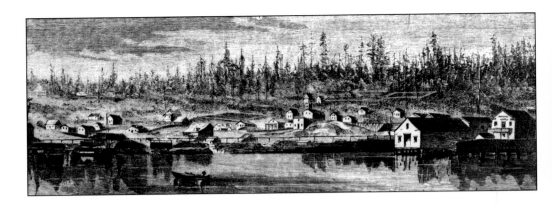

CHANGING SKYLINES, 1870 (ABOVE) AND 1920 (BELOW). The above sketch of Seattle, which appeared in *Harper's Magazine* in 1870, shows that the skyline still had trees on the crest of the hills and that the settlers had begun to fortify the shoreline with logs for stability—the beginning of Seattle's seawall. In the 1920 view of Seattle's skyline, the natural environment of towering trees has been replaced with a built urban environment of soaring buildings. In 1920, Seattle's Smith Tower (visible at left in the below image) was still the tallest building in Seattle and west of the Mississippi. Wharfs that supported commerce and marine vessels along Seattle's central waterfront had been built and rebuilt a number of times. King County voters approved the Port of Seattle in 1911. (Above, courtesy SPL_shp_14557; below, courtesy TPL.)

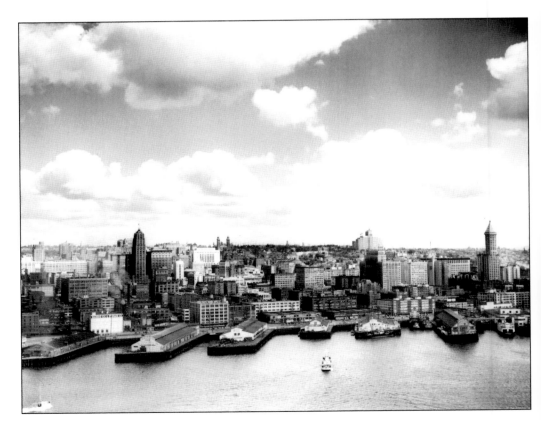

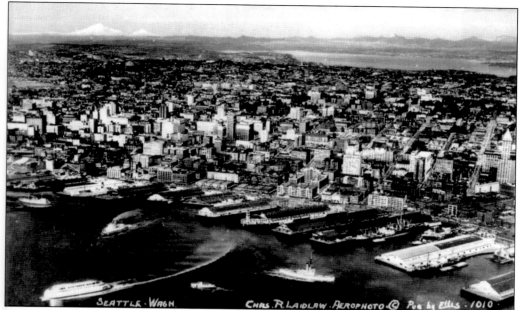

CHANGING SKYLINES, 1940s AND 1950s. Both of these images illustrate the importance of marine vessels for commerce, transportation, and recreation. The density of the urban environment and the height of the structures continued to increase over time. Despite the fact that the naming (numbers, words, or letters) of the piers changed, the piers themselves remained stationary per the design of city engineer R.H. Thomson during his powerful reign. The above image shows Alaskan Way without an elevated viaduct; the below image shows Alaskan Way with the viaduct, which was constructed in phases during the 1950s. The reinforced-concrete structure has provided a north-south route for vehicular traffic for nearly 70 years. It is projected to be demolished and replaced with the world's largest-diameter tunnel by 2020. (Above, courtesy WSHS-1994.36.19; below, courtesy SPL-shp-21634.)

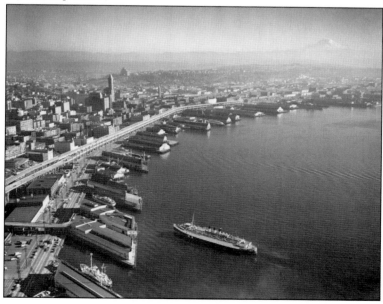

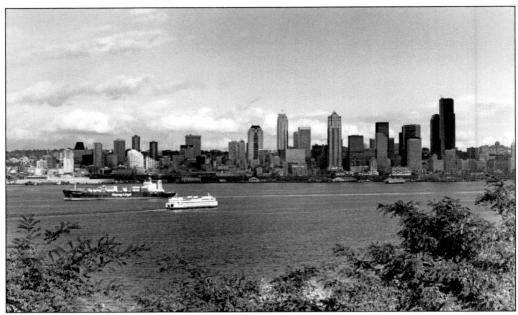

CHANGING SKYLINES, 1985 (ABOVE) AND 2001 (BELOW). Ferries continue to provide critical transportation for daily commuters from around Puget Sound to Seattle, as well as offering a beautiful experience for tourists. A quiet, smooth landing/departure at Seattle is a magnificent experience that should be enjoyed by all. Seattle's skyline continues to increase in density and height, as illustrated in these photographs. The Alaskan Way Viaduct is clearly visible in the image from 2001—the same year that the Nisqually earthquake shook the Seattle region and alerted the public to the fragile nature of both Seattle's seawall and the Alaskan Way Viaduct. (Above, courtesy SMA-57738; below, courtesy SMA-112975.)

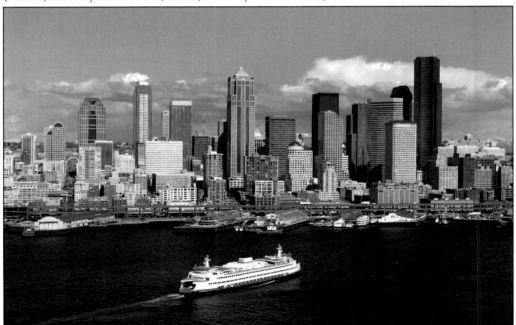

Five

WORKING WATERFRONT

The gritty working waterfront—a hub for cargo-handling, warehousing, commerce, and transportation—emerged during the first quarter of the 20th century. As the port and city grew, city engineer Reginald Thomson was busy laying out piers, regrading Seattle's seven hills, rebuilding streetcars, digging train tunnels, and installing sewer and water lines. The shorelines continued to change with the massive undertaking of regrading, which eventually eliminated several of Seattle's famed hills. Depositing the dirt and structures in Seattle's wetlands and estuaries changed the environmental landscape forever. In 1910, a concrete seawall was built south of Madison Street; then, in 1936, a new and improved seawall was built north of Madison Street to keep the newly deposited fill in and the tide out—and to hold up the city streets so vital for transportation and commerce. The earlier wall at Front Street (now First Avenue) was more like a bulkhead that served to shore up the hillside.

Seattle's port continued to grow and was spurred on by both World Wars, when shipbuilding and, later, the aerospace industry fueled the economy with jobs for both men and women. Many labor groups organized along Seattle's waterfront, prompting strikes and controversy that sparked activity in the area. Tugboats, ferries, freighters, fishing fleets, the Puget Sound Mosquito Fleet, and other types of watercraft remained prominent parts of the local culture, business, and transportation.

As the city grew, the primary modes of transportation shifted from water to horse-and-buggies to trains to automobiles. The mounting congestion was compounded by the physical limitations of the city, with Elliott Bay to the west, Lake Washington and steep unstable slopes to the east, Lake Union in the middle, and filled wetlands to the south. Seattle struggled with a transportation solution while it lived in gridlock. The east-west movement of goods and people across Railroad Avenue (now Alaskan Way) was a particularly vexing problem that continues today.

Meanwhile, a less visible problem had also emerged. Water pollution in Elliott Bay, the Duwamish River, and other major bodies of water in the area began to cause health problems for people and toxic environmental habitats for flora and fauna. The formerly pristine waters of the Whulge and contributory rivers and lakes were no longer swimmable, fishable, or drinkable.

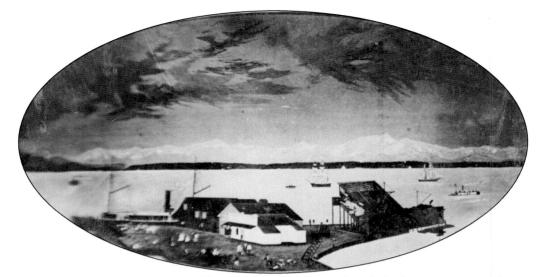

YESLER'S MILL AND COOKHOUSE. From its very beginning, Seattle had a working waterfront. Within the first year of settlers moving to the east side of Elliott Bay in 1852, Doc Maynard was able to entice Henry Yesler to build Puget Sound's first steam-powered sawmill at Seattle's Pioneer Square. Yesler heavily depended upon local native Indian populations (Duwamish, Suquamish, and other Salish tribes) to help with logging, transporting, and milling the trees. Once the mill was in operation, labor also came from ship crews that contained a variety of ethnic groups. (Above, courtesy SPL-shs_5125; below, courtesy SPL_shs_15219.)

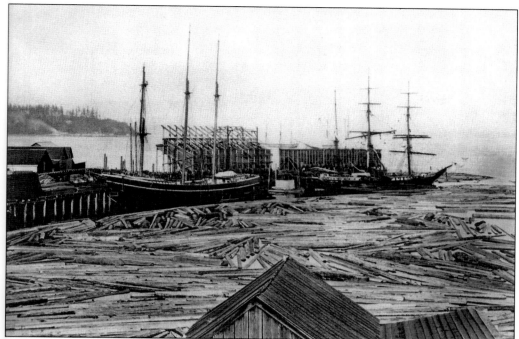

YESLER'S MILL, 1870s (BELOW), AND YESLER'S WHARF, 1880 (ABOVE). Docks or wharfs were critical to the functioning of Seattle's waterfront. Without the wharfs, it would be almost impossible to load and unload ships. Yesler's Wharf was initially built in 1853 but was expanded and rebuilt several times, both before and after the 1889 fire. The above image shows of Yesler's Wharf in 1880 with sailing ships moored at the dock. Logs, many of which were used for ship mast, float in the water as they await export on ships or milling in Yesler's Mill. The below image shows Yesler's Mill and the lagoon. The forest line then was around the present-day location of Sixth Avenue. (Above, courtesy MOHAI-7313; below, courtesy SPL.)

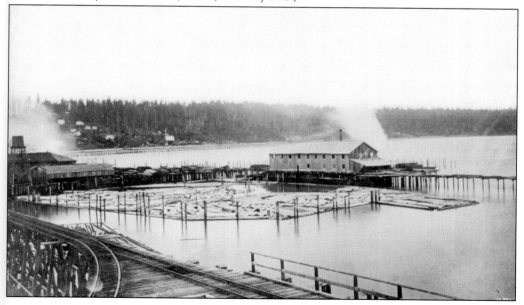

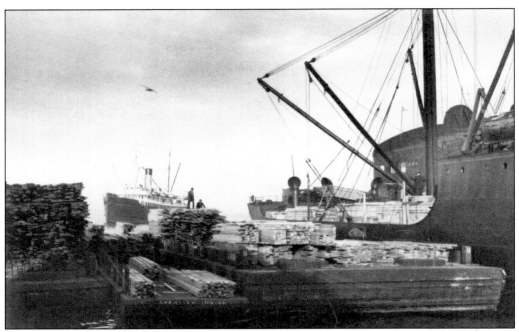

LOADING LUMBER AND FISH ON THE WHARFS. Natural resource extraction provided the initial economic engine for Seattle. Above, processed lumber is being loaded from a barge onto a steamship in the 1920s. Below, men unload salmon from a river barge into huge bins on a dock along Seattle's waterfront around 1900. The fish were most likely taken to one of the many processing and canning facilities located on the waterfront. Untreated waste from the processing plants was discharged into Elliott Bay for decades. Habitat destruction, water quality issues, and overfishing, among other factors, contributed to several salmon species being listed as threatened and endangered species in 2000. (Above, courtesy WSHS-1974.35.287; below, courtesy WSHS-1994.123.121.)

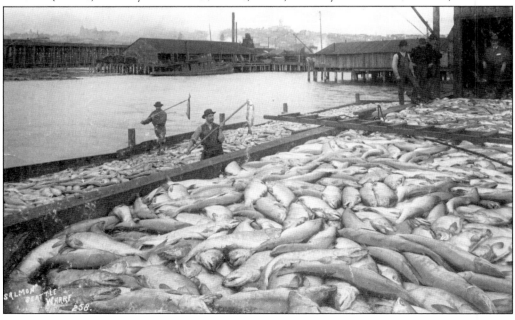

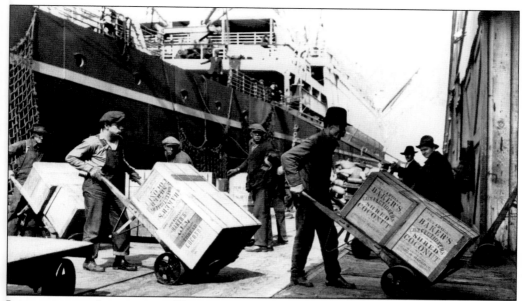

LONGSHOREMAN LOADING AND UNLOADING CARGO. Prior to mechanization of the port, manual labor was critical for loading and unloading sailing ships and steamers. In the c. 1906 image above, longshoremen unload cargo from a freighter using hand trucks. Below, longshoremen move cargo manually from a warehouse to sailing ships in about 1920. The rigging and ropes (possibly from the Pacific Net and Twine Company—see pages 78 and 79) on the ship and docks were essential, performing many functions to secure and move cargo. (Above, courtesy MOAHI-shs-7490; below, courtesy WSA-Port of Seattle100.org-4446.)

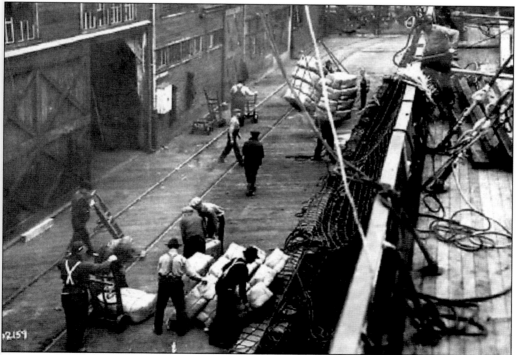

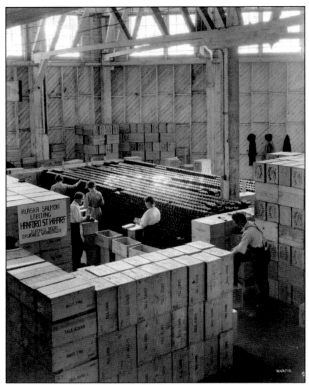

INTERIOR WAREHOUSE AND FOOD PROCESSING. Products arriving via sail, rail, or road often needed to be processed before further distribution. The image at left shows the interior of a warehouse at Hanford Wharf (now Pier 25) where salmon was canned, labeled, and packed for shipment. The c. 1919 image below shows women cleaning strawberries brought from the surrounding Puget Sound area during the berry season (June and July). The strawberry-processing plant was located inside the Spokane Street terminal (now Pier 24). After the berries were cleaned, they were placed in cold storage. Women were active in some sectors of the workforce; factory work was one type of job women were allowed to perform in the early 20th century. (Left, courtesy MOHAI-9217; below, courtesy MOHAI-7309.)

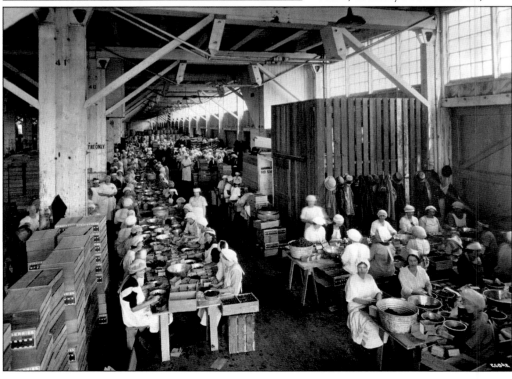

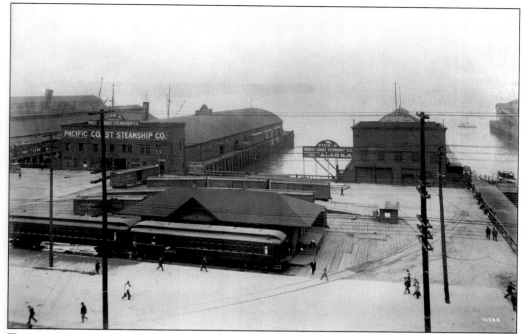

TRANSPORTATION HUB. Multimodal transportation coordination is a goal that Seattle has recognized for more than a century. Above, the Pacific Coast Steamship Company—located on Pier B between Main and Jackson Streets—is visible in the background, and the Columbia & Puget Sound Railroad station is in the foreground, linking rail to sail. The Pacific Coast Steamship Company, based in San Francisco, operated steamships in Puget Sound as well as routes from Seattle to Alaska. Founded in 1856, it held a monopoly on these routes until the Seattle-based Alaska Steamship Company arrived on the scene in the late 1890s. The Pacific Coast Steamship Company ceased operation in 1936. Below, crowds flock to Seattle's waterfront as they prepare to journey to the Klondike goldfields in 1897. Seattle became the "Gateway to the Klondike" after the discovery of gold in Alaska. (Above, courtesy MOHAI-1978.6585.2; below, courtesy SPL-2315.)

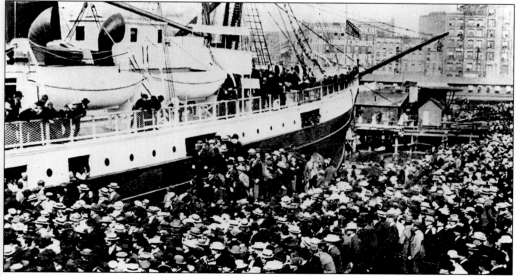

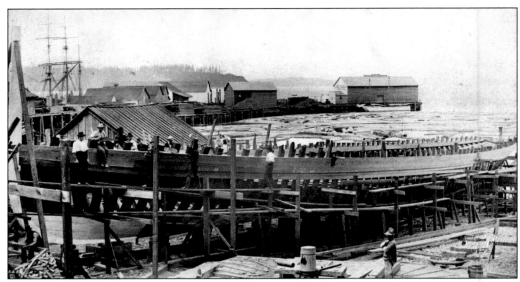

SHIPYARDS. Shipbuilding was an important industry in Seattle for many years. In the above image, the steamer *George E. Starr* is under construction at William Hammon's shipyard, located on the waterfront between Columbia and Cherry Streets. Launched in 1879, the *George E. Starr* provided service between Seattle, Tacoma, and Port Townsend. Below is the Moran Brothers Company shipyard, located on Seattle's Waterfront between Charles and Dearborn Streets. Covering 28 acres of reclaimed tidelands, the Moran shipyard operated from 1882 to 1906 and produced many ships during its tenure, including the 12 paddle-wheel riverboats built to provide service to the Klondike goldfields. Moran Brothers also built the USS *Nebraska*, commissioned in 1907 to participate in the Great White Fleet's World Cruise in 1909, and which eventually served in World War I. Moran Brothers company president Robert Moran served as the mayor of Seattle from 1888 to 1890. (Above, courtesy SPL-5211; below, courtesy TPL-Fleming294.)

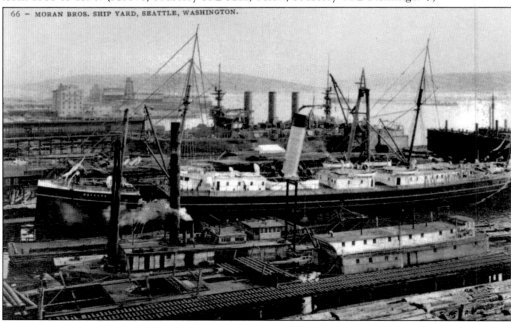

66 – MORAN BROS. SHIP YARD, SEATTLE, WASHINGTON.

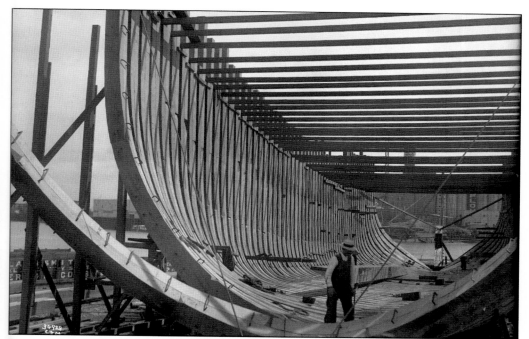

BOATBUILDING. Seattle hosted many launchings during the shipbuilding boom, which peaked during World War I (1916 to 1918) and was revived during World War II. Above, shipbuilders work on a wooden hull at the Nilson & Kelez Shipbuilding Corporation on Seattle's waterfront in 1916. Below, the *Cape Alava* is being launched from the Seattle-Tacoma Shipbuilding Company dry dock. (Above, courtesy WSHS-1943.42.34929; below, courtesy TPL.)

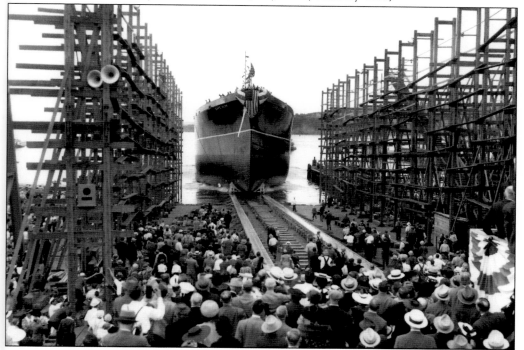

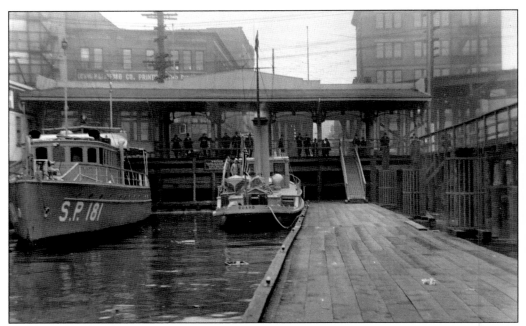

WASHINGTON STREET LANDING. These two images show Washington Street Landing, one of the waterfront's iconic landmarks, from two different perspectives. The image above is a view from the water when arriving by boat to the landing, which is also known as the Harbor Patrol Dock and Navy Landing. The image below shows the end of Washington Street, where one could board a boat, view the water, catch a fish, or report to the harbor patrol. The Washington Street Landing is being refurbished as part of the future Seattle waterfront. (Above, courtesy SMA-77200; below, courtesy SMA-2705-5820.)

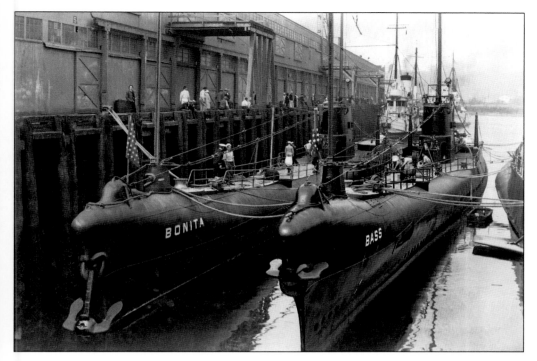

SUBMARINES AND AIR FERRY LINE. Seattle's waterfront has been and continues to be home to many types of land, sea, and air transportation. Above, the USS *Bonita* and USS *Bass* submarines are moored around 1930. Below, a c. 1933 photograph shows Pier 3 and a biplane used by Gorst Air Transport, Inc., to ferry passengers between Seattle and Bremerton. (Courtesy MOHAI-2002.30.8 and MOHAI-1987.45.15.)

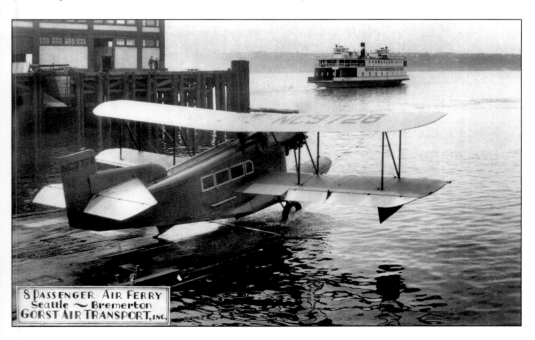

8 PASSENGER AIR FERRY
Seattle ~ Bremerton
GORST AIR TRANSPORT, INC.

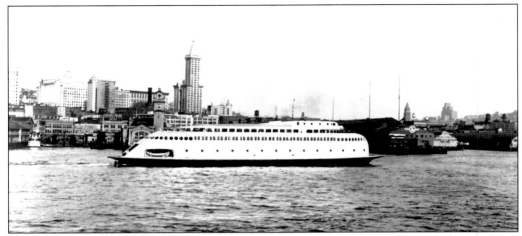

SEATTLE'S FERRIES. One has not fully experienced Seattle's waterfront if he or she has not been on a ferry. There is nothing quite like gliding on Puget Sound while arriving to or departing from Seattle, with the skyline growing or diminishing, the sea breeze blowing, the smell of marine waters, and the resonant horn of the ferry reverberating throughout one's body. No matter the weather, the experience is thrilling. Each day, thousands of commuters take the ferries to work in downtown Seattle. Above, the *Kalakala* ferry—an iconic vessel that served from the 1930s through the 1950s—glides along Seattle's waterfront. Below, passengers could read, sleep, eat, chat, or take a walk on the deck as part of their daily commute. (Above, courtesy MOHAI-1983.10.17698.2; below, courtesy MOHAI-1986.5.13625.3; SMA.)

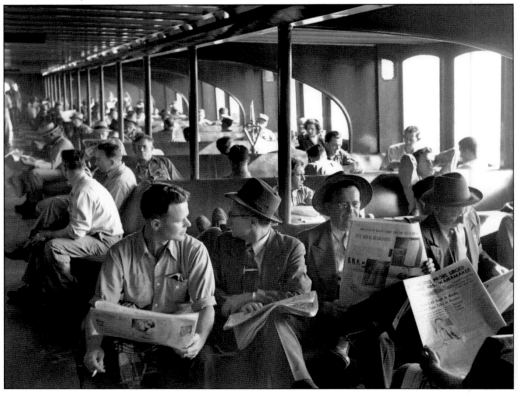

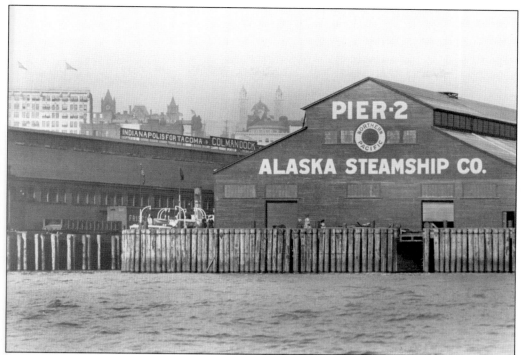

ALASKA STEAMSHIP COMPANY.
Incorporated in 1894, the Seattle-based Alaska Steamship Company broke the monopoly held by the Pacific Coast Steamship Company, which was based in San Francisco. The Alaska Steamship Company occupied Piers 1 and 2, located at the foot of Yesler Way and Marion Street. Thousands of Alaskans traveled to and from the "outside" via Alaska Steamship Company steamers, along with tourists and adventurers from around the world who ventured to the land of the midnight sun. In *Alaska Steam*, Robert Hennings writes, "Many tiny ports . . . lived by the infrequent arrivals of the Alaska Steamships. Alaskans, from Kougarok to Ketichan, all had to use the same ships to get "Outside" to Seattle . . . Sometimes it would take as much as twelve days for a vessel to make its otherwise four-day run from Seward to Seattle, stopping at canneries for canned salmon packs . . . at struggling mines for concentrate, at salteries and reduction plants for their season's production." (Above, courtesy UWSC-0951; right, courtesy SPL_SHP_20069.)

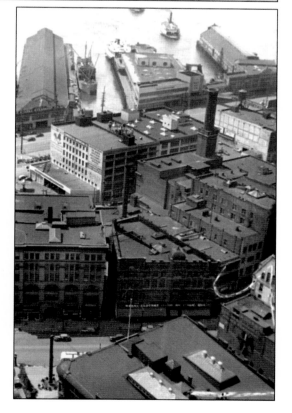

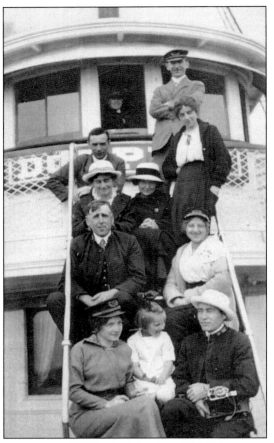

ALASKA STEAMSHIP CRUISE. John Bunch was the general freight and passenger agent for the Alaska Steamship Company from 1908 to 1920. One benefit of the job was first-class travel at a highly discounted rate. The guests of honor on a c. 1916 cruise to Alaska on the SS *Dolphin* are pictured at left and included Lionel Bunch, John's son; Chloe, Lionel's wife; Ethel Keniston, Chloe's cousin; Annie Keniston, her aunt; and Sir Huber Wilkens from Australia. The steamer's ports of call included Bella Bella, Juneau, Wrangle, Treadwell, Skagway, Ketichan, Cordova, Valdez, and Anchorage. Look closely at the image at left and note that the crew and passengers have exchanged hats. The Bunch and Keniston families surely experienced what *Alaska Steam* author Robert Hennings describes as "traditional midnight lunches, the three-piece combos of girl orchestra's . . . and a skipper always popular with the ladies who liked the schottische, the hambo, the varsoviana and the polkas . . . and the last night aboard, the Captain's Dinner which was often a masquerade." (Left, courtesy Keniston-Driscoll; below, courtesy WSHS-1943.42.138.)

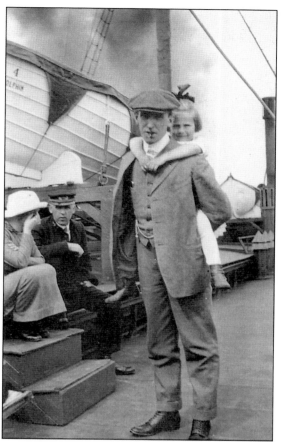

ALASKAN EXPEDITIONS. With moderately-sized steamers, it was easy for tourists to meet new people on board. The Bunch-Keniston party met Sir Hubert Wilkins, an explorer associated with Vilhjalmur Stefansson during the 1913 polar exploration, while on their 1916 cruise to Alaska. In the July 1959 edition of *Reader's Digest*, Stefansson authored an article dedicated to Wilkins, who is pictured on board the Alaska Steamship Company's SS *Dolphin* with the Bunches and Kenistons on the previous page. They became fast friends over the dinner table, had a good time dancing afterward, and continued to correspond over the years. Lionel Bunch is pictured at right carrying his daughter, whose name is not known. (Both, courtesy Keniston-Driscoll.)

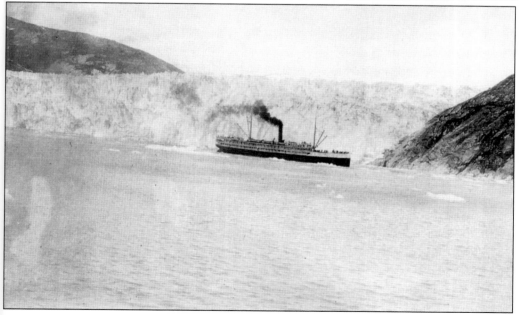

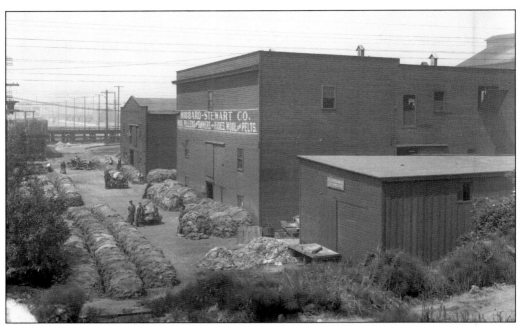

SEATTLE FUR EXCHANGE. The Seattle Fur Exchange was established in the 1890s to provide a means for trappers in remote areas of Alaska to trade pelts for supplies such as food, clothes, and tools. In turn, the pelts were transferred from the far reaches of Alaska and shipped to Seattle for auction to wholesalers around the world. The fur exchange's warehouse (above) was located at 17 Madison Street. In the 1940s, the sales office (below) was relocated to 2400 First Avenue to avoid the railcar mess on Railroad Avenue and to better serve wholesale and retail clients. (Above, courtesy WSHS-1943-42.690; below, courtesy WSHS-xxx.)

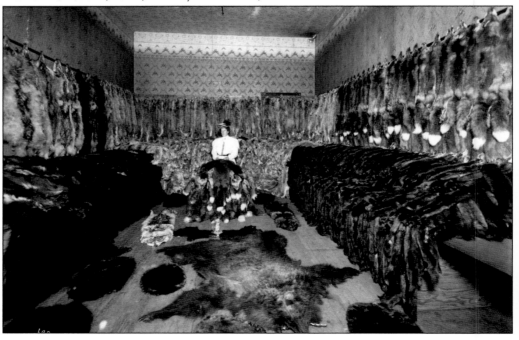

ALASKA TO SEATTLE. In the image at right, Hugo Tollefson holds a distinctive black wolf pelt in the winter wonderland outside of Talkeetna, Alaska. Below, Jim Beaver is trading a pelt at Nageley's (B&K Trading Post) in Talkeetna, Alaska, around 1940. Prior to the 1920s, pelts like these traveled via riverboats built in Seattle; however, once the Alaska Railroad was completed, pelts were shipped via rail to Anchorage or Seward, then loaded onto Alaska Steamship Company steamers for auction at the Seattle Fur Exchange. In 1936, Railroad Avenue was renamed Alaskan Way due to the significant economic and social connections between Seattle and Alaska. The vast majority of supplies shipped to Alaska originated in Seattle, while Alaska shipped fish, gold, and furs to Seattle. (Both, courtesy THS.)

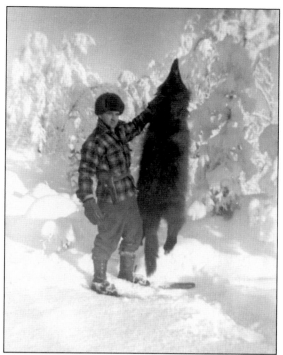

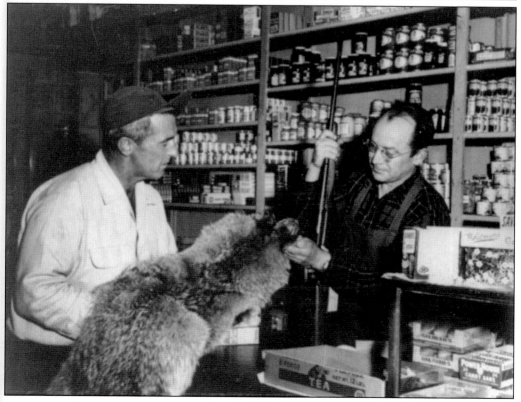

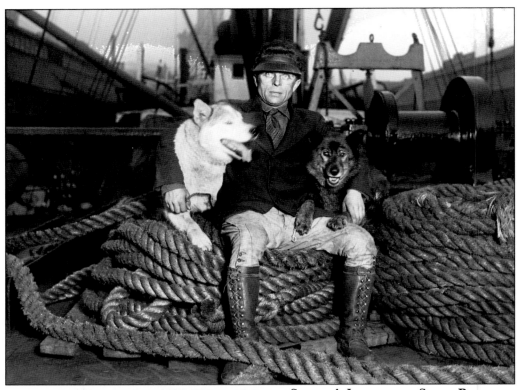

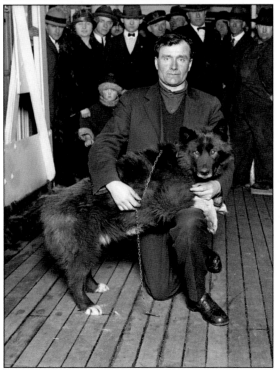

SEATTLE'S LINK TO THE SERUM RUN TO NOME, ALASKA. The steamer *Alameda* of the Alaska Steamship Company provided transportation from Alaska to Seattle for sled dogs and mushers Gunnar Kaasen (left, with Balto) and Leonhard Seppala (above, with Fritz at left and Togo at right). Nome experienced a diphtheria epidemic in 1925 and became an international news story when area waters froze over, blocking ship access to Nome. Dog sled was the only means of delivering the serum that would save the population. The antitoxin serum relay run followed the US mail route. Balto was the lead dog for the last leg of the run, which was undertaken by Kaasen. Togo served as Seppala's lead dog for the majority of the race against time. Seppala retired in Seattle's Ballard neighborhood. Both of these photographs were taken on Pier 2. The Alaska-Yukon Pioneers Committee presented a bone-shaped key to the city to Balto on March 22, 1926. (Above, courtesy MOHAI-19865G.2757; left, courtesy MOHAI-19865G.1291.)

Togo, Nurse Emily Morgan, and Seattle.
Emily Morgan, who traveled through Seattle on her way from Wichita, Kansas, to Nome, Alaska, was the lead nurse during the diphtheria epidemic. Also known as the "Angel of the Yukon," Morgan is pictured at right with Togo, the lead dog for the majority of the serum relay that crossed Alaska in 1925. Morgan's grand-nieces Mary Atzbach (left) and Diana Turner (right), who call Seattle home, are pictured below on Seattle's waterfront holding the International Film Festival poster for the 2013 premiere of *Icebound* and a picture of their great aunt, respectively. Directed and produced by Daniel Anker, this spellbinding documentary about the Alaskan serum run is a breathtaking real-life adventure tale of dogs and heroes in the frozen Arctic. The 1925 serum run inspired the Iditarod race and route. (Both, courtesy Morgan family.)

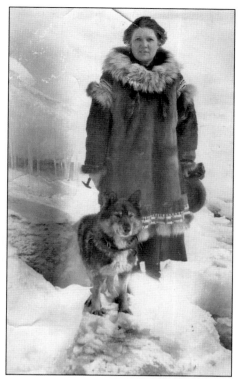

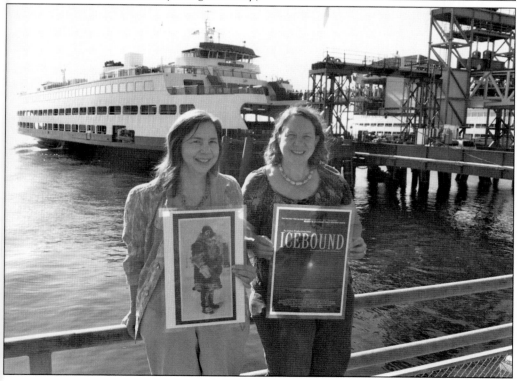

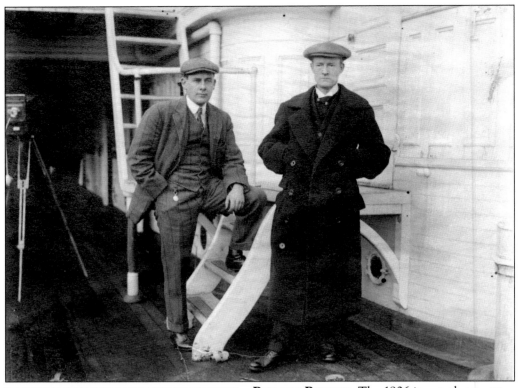

BELMORE BROWNE. The 1906 image above was taken on a steamship en route to Alaska that contained explorer, mountain climber, and artist Belmore Browne, his team (Herschel, Clifford, and Parker), and their supplies. Belmore was the son of George Browne, founder of the St. Paul & Tacoma Lumber Company in the 1880s. His expedition played an important part in the exploration, mapping, and climbing history of Denali, or Mount McKinley, the highest point in North America. In his book *The Conquest of Mount McKinley*, Browne writes, "At this time the pack-horse was the only method of transportation that had been used in reaching the mountain, and we therefore secured a pack-train of twenty carefully chosen horses from the celebrated stock-ranges east of the Cascade Mountains in the State of Washington . . . On our way to Alaska, the horses were housed in specially constructed stalls on the forward deck of the steamer." The image at left illustrates how the horses were loaded onto the steamer from Pier 2 in Seattle. (Above, courtesy DCL-SteffMss-190-6-20-a; left, courtesy WSHS-S1992.27.336.2)

PROVISIONS FOR MOUNTAIN TREKKING (ABOVE) AND A SEATTLE-BUILT BOAT (BELOW). Above, the Washington horses that Browne had loaded in Seattle are pictured in the sweeping landscape of the Alaska Range. Horses carried all supplies for Browne and his team until they reached snow level. After arriving in Alaska, Browne's team purchased dogs to pull sleds carrying supplies as they attempted to reach the top of Denali (Mount McKinley) with climbing supplies and equipment purchased in Seattle. Below, the *Alice Susitna*, a riverboat built by Moran Brothers Company in Seattle, is docked at Talkeetna in 1906. Today, Talkeetna is the historic village that mountain climbers from around the world use as a starting point when attempting to summit Mount McKinley, North America's tallest peak. (Above, courtesy DCL-Steffmss-190-5-1-23; below, courtesy DCL-Steffmss-190-4-50-a.)

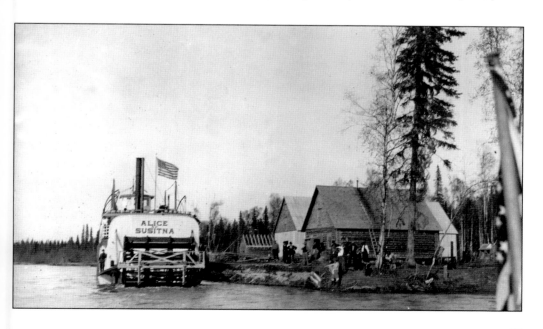

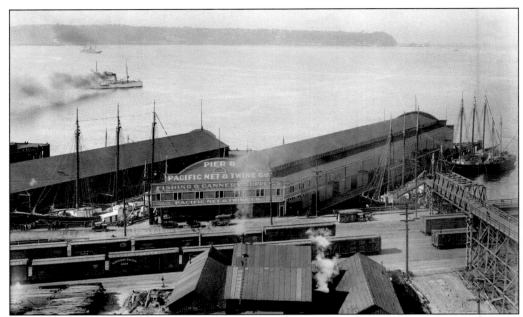

PACIFIC NET & TWINE COMPANY. Pier 6, at the foot of University Street, and Pier 8, on Railroad Avenue, housed Pacific Net & Twine in 1900 and 1915, respectively. Edward Cunningham established the company in Seattle in 1897, providing Puget Sound and the Alaskan fishing industry with fishing equipment, marine hardware, and ship stores (netting, cordage, canning materials, and other marine/fishing supplies). The importance of these supplies cannot be overemphasized, as they provided safety and livelihoods for the large number of diverse ethnic groups who fished these waters. The above image illustrates how the north-south corridor was devoted to the multiple railroad companies that operated many tracks on Railroad Avenue. East-west passage was a significant challenge for loading and unloading ships and moving goods and people to or from the piers and docks. The east-west corridors did not have clear sightlines—only views of tracks and trains. (Above, courtesy MOHAI 2007.4.12; below, courtesy UWSC-SEA2940.)

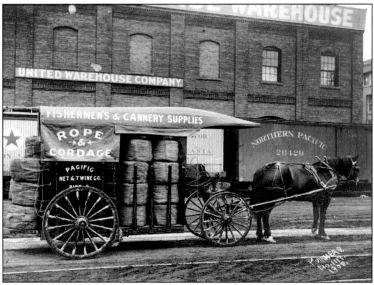

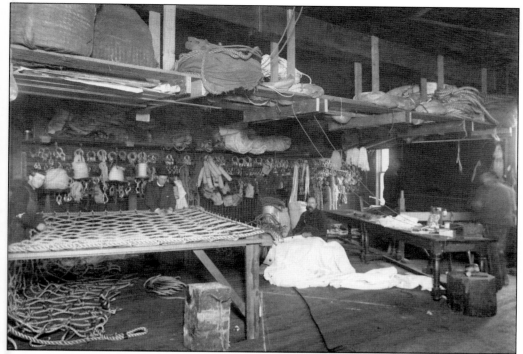

PACIFIC NET & TWINE COMPANY STORE. The above image offers a view of the products that the Pacific Net & Twine Company produced, stored, and sold, which were vital components of the fishing industry in both Seattle and Alaska. While it was essential to have water access for easy loading of supplies onto the vessels, it was difficult for non-watercraft customers to reach the Pacific Net & Twine Company business office due to the danger involved in crossing Railroad Avenue. As a solution to this problem, Pacific Net & Twine opened a shop at 1223 Western Avenue. The c. 1904 image below shows the company's store at First and Jackson Streets. (Above, courtesy MOHAI-2007.4.32; below, courtesy MOHAI-2007.4.2.)

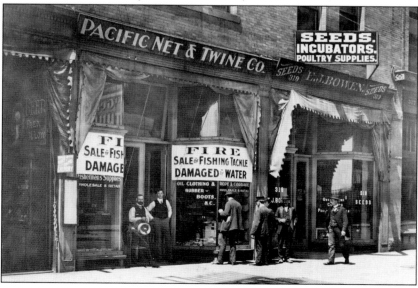

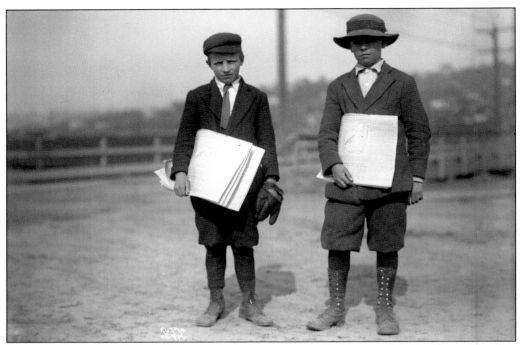

EXTRA! EXTRA! READ ALL ABOUT IT! If anything noteworthy happened in Seattle, it was often on the waterfront. The two unidentified newspaper boys above may have been selling special editions of newspapers announcing exciting news—perhaps the discovery of gold in 1897 or the arrival of Pres. Theodore Roosevelt to Seattle's waterfront in July 1903. Below, throngs of crowds streamed to Seattle's waterfront to greet Roosevelt as he disembarked from the SS *Spokane* at Pier 1. (Above, courtesy WSHS-1943.42.26770; below, courtesy MOHAI-2002.3.11.)

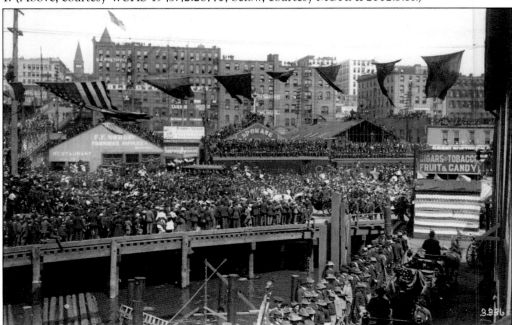

WOMEN'S RIGHTS AND SAVE THE WHALES.
Over the centuries, protests have been a
common sight along Seattle's waterfront,
with protesters calling attention to a wide
variety of causes such as labor disputes,
environmental issues, and equality. In the
image at right, a protester campaigns for
women's rights during an equal-rights rally
held at Seattle's Waterfront Park in 1977;
below, people of all ages demonstrate to
"save the whales!" in Seattle's Waterfront
Park in April 1975. It is estimated that
the historic high count for Puget Sound
orca pods J, K, and L was 200 in the early
1800s. According to NOAA Fisheries,
"Beginning in the late 1960s, the live-
capture fishery for oceanarium display
removed an estimated 47 whales and
caused an immediate decline in Southern
Resident numbers. By 2003, the population
increased to 83 whales. The National
Marine Fisheries Service listed this
segment of the population as endangered
under the Endangered Species Act in 2005
and designated 2,560 square miles of inland
waters of Washington State as critical
habitat in 2006." (Right, courtesy USWC-
MPH-1101; below, courtesy UWSC.)

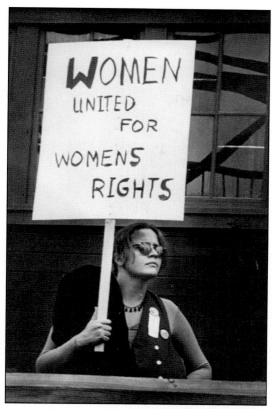

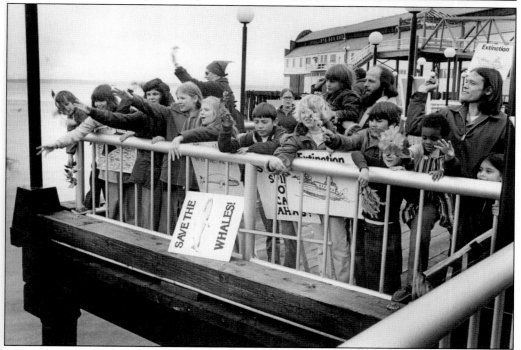

EQUAL RIGHTS AMENDMENT AND SEAFAIR PIRATES. The crowd of people pictured at left gathered for a rally at Seattle's Waterfront Park in August 1977 to demonstrate and support the proposed Equal Rights Amendment. The Alaskan Way Viaduct is visible in the background. Note how sparse the city skyline was in 1977. The demonstrators marched from the old federal courthouse, located at Fifth Avenue and Madison Street, to Waterfront Park. The peaceful rally lasted for four hours. Below, pirates arrive at Seattle's waterfront for the annual Seafair extravaganza—an annual event that features parades, air shows, and hydroplane races on Lake Washington. (Left, courtesy UWSC; below, courtesy UWSC-SOC-3599.)

Six

SEATTLE'S SEAWALL

"Change" is the word that best describes Seattle's waterfront: an ever-changing shoreline as the tide rises and falls; a shifting shoreline. The transition from water to estuarine aquatic lands to uplands played a unique role in the ecosystem. The few parcels of land that did not have high banks were sought after for housing, business, and wharfs for commerce and transportation. While these lowlands proved ideal for building, they also struggled with water from incoming tides; waves from strong winds (in combination with heavy rainfall) created frequent flooding of streets and basements and ponding throughout Seattle's waterfront. Seattle's solution to control the incoming tidal issues was to build a seawall to keep the water out of the city and to hold up the city.

The first images of Seattle's seawalls date from the 1860s, with logs serving as the barrier or bulkhead between the sea and land. Over time, the logs were gradually replaced with rocks, bricks, and cement. Starting in 1914 and through the 1930s, extensive public works projects created the basis for the seawall that most Seattleites recognize today. The materials from the 1930s eventually succumbed to the elements—salt water, teredos, and gribbles—that slowly ate away the seawall's structural integrity.

After the 2001 Nisqually Earthquake, the Seattle Department of Transportation and the Washington State Department of Transportation declared that the seawall structure had a one-in-ten chance of failure due to a seismic event. This triggered the drawn-out saga of not only figuring out how to fix the seawall so the city would not fall into the sea, but also what to do with the Alaskan Way Viaduct and the 110,000 vehicles it supported each day.

These discussions led to an extensive public process of Seattle redefining what the waterfront should be today and for future generations. The public process will create a vision and a completed project by mid-2020 if funding is available to implement Seattle's future vision of the waterfront and related projects, such as the bored tunnel and Elliott Bay seawall, remain on schedule.

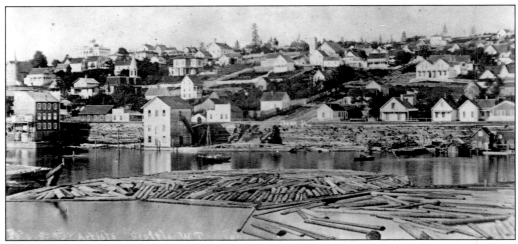

LOG BULKHEADS, 1878. The first vestiges of a seawall can be seen in these 1878 images. Logs from local trees were used to reinforce portions of the banks along Seattle's waterfront and keep them from sloughing into the bay. Above, Front Street (now First Avenue) parallels the shoreline from Madison Street (on the north end) to Columbia Street (on the south end), where the image was taken looking northeast. By 1878, the first of many regrades had been completed. Below is a closer view of the log seawall. Note the floating logs in Elliott Bay in the foreground of both images, reflecting the importance of forestry and logging to the local economy at this time. By 1878, there were just a few trees left on the hilltop ridges. (Above, courtesy SPL_shp_5064; below, courtesy UWSC-Curl1189.)

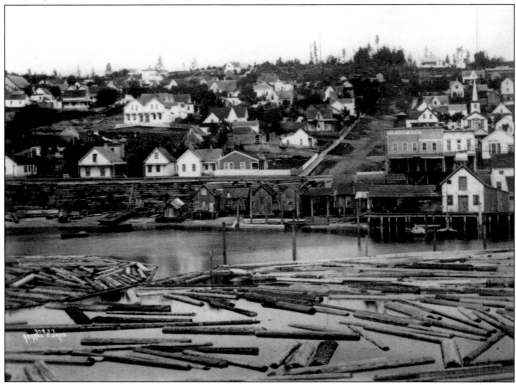

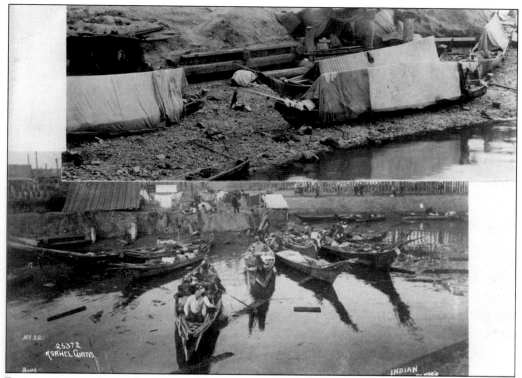

BALLAST ISLAND (ABOVE) AND THE SEAWALL (BELOW), 1917. Ballast Island was formed as sailing ships dumped unwanted ballast into the water at the foot of Washington and Main Streets. In early 1865, the Seattle city council passed an ordinance banning Native Americans from living within city limits. Native Americans were allowed to live on Ballast Island until the 1890s, when that land was deemed useful to the city. Ballast Island formed a pseudo seawall, stabilizing the uplands behind it and providing a place for temporary housing and for canoes to dock. The first concrete gravity seawall was constructed in 1916. The below image shows the wall at the foot of Madison Street, demonstrating how it keeps out the water and supports streets, sidewalks, and soil on the upland side of the wall. (Above, courtesy SPL; below, courtesy SMA-1223.)

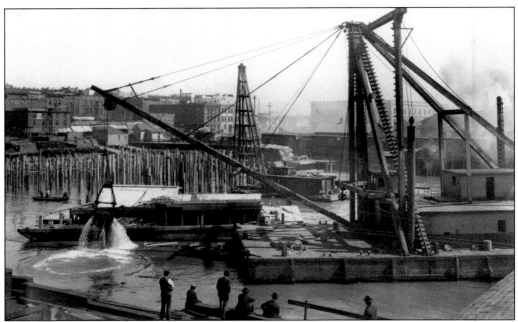

DREDGING, 1902 (ABOVE), AND BALLAST ISLAND (BELOW). Piling and dredging between Piers 1 and 2 (used by the Alaskan Steamship Company) is being completed in the above image. Dredging was required to ensure the water was deep enough for loaded ships arriving at and departing from the Alaskan Steamship Company. Berthing or docking areas would gradually fill with sediment from natural tidal progressions, slough from bluffs and shorelines, turbulence from ships, and runoff from uplands that had been cleared of vegetation. Below is Ballast Island, so named for the ships dumping ballast in the water and near shore. Native Americans lived on the island after the Seattle city council banned them from living within the city limits in 1865. Eventually, Ballast Island was deemed to be desirable for development, and the Native Americans had to move again. (Above, courtesy WSHS-1943-42.26372; below, courtesy UWSC-CUR1689.)

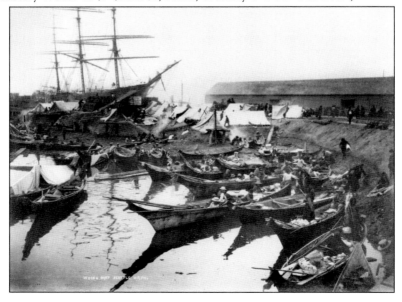

TEREDOS AND GRIBBLES (RIGHT), AND THE RAILROAD AVENUE SLANTED PILES (BELOW). From the installation of the first seawall along Seattle's waterfront, Mother Nature has continued her relentless assault on its various materials, and the appetites of marine organisms called teredos and gribbles have gradually rendered the engineered seawall structurally unsound. At right is a close-up of the gribbles, which have wreaked havoc on the seawall and its supporting structures for nearly a century. Below is a view of what lies behind the seawall and under the thoroughfare built along the central waterfront between 1934 and 1936. This image shows slanted piles under Railroad Avenue and Bay Street in 1934, when the seawall was being built. (Right, courtesy SMA-1222; below, courtesy SMA-8821.)

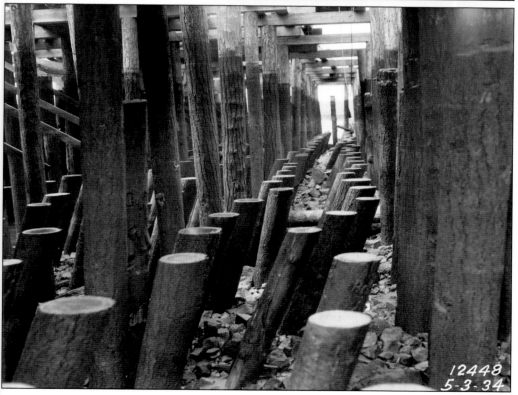

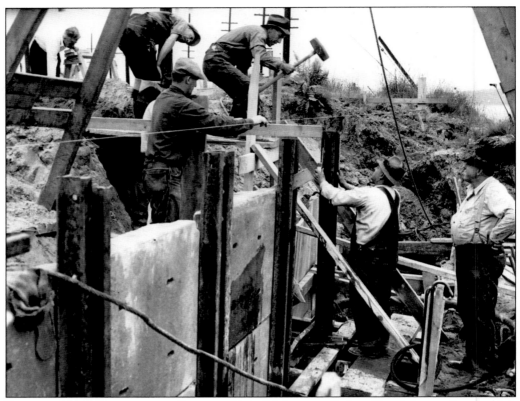

BUILDING COFFERDAMS FOR THE SEAWALL. To build the seawall along Seattle's waterfront, which had been discussed since the 1890s and was finally funded in 1934, cofferdams were constructed to provide dry working conditions along the proposed seawall alignment. A cofferdam is a temporary structure that is built to pump out water and create a dry environment needed for a variety of construction techniques. This was particularly important along Seattle's waterfront, where the tide rises and falls twice a day. The above image, which looks north from near Pier 7 (Railroad Avenue), shows workers constructing the cofferdam. Note their clothing, which would not meet current OSHA safety standards. Below is an interior view of a cofferdam. (Above, courtesy WSHS-2010.0.250.36.10; below, courtesy SMA-73220.)

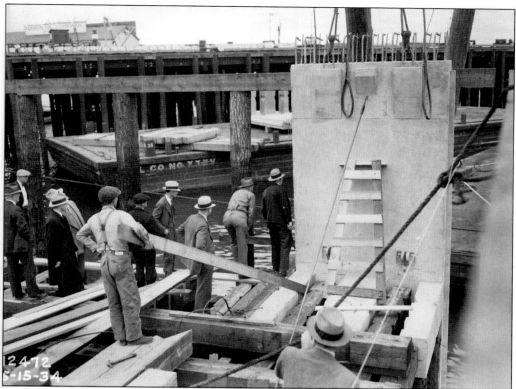

BUILDING AND PLACING THE FIRST CONCRETE SLAB SEAWALL, 1934. Above, precast slabs and forms with rebar are ready for pouring concrete along Railroad Avenue south of Bay Street. Below, the first slab of precast seawall is being placed along Railroad Avenue. This new seawall would permanently change the appearance and function of Seattle's shoreline. The seawall was located up to four blocks west of the original natural shoreline, which had gradually crept into the aquatic lands due to fill from the regrading of the surrounding area and the dumping of industry waste materials and the remnants from the Great Fire of 1889. (Above, courtesy SMA-8888; below, courtesy SMA-8845.)

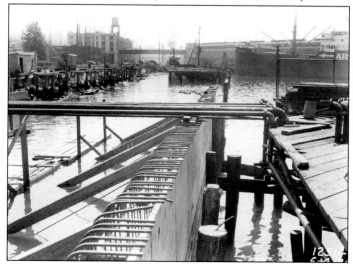

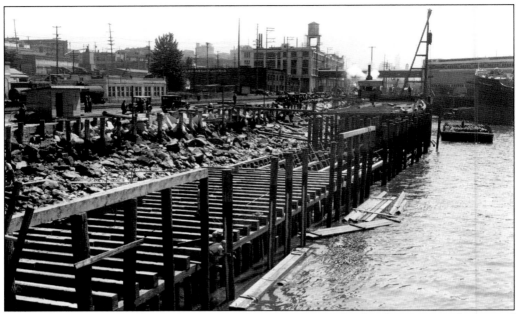

PILE-DRIVING AND SEALING SEAWALL WITH CONCRETE, 1934. In the above image, the natural shoreline is visible behind the framing work for cofferdams and the newly proposed seawall. Rocks and piles had previously been installed to stabilize the slope and provide a buffer from the waves and tides for upland functions. Below, men at work on the new seawall along Railroad Avenue and Broad Street are facing, or sealing, the seawall with concrete. (Above, courtesy SMA-8867; below, courtesy SMA-9011.)

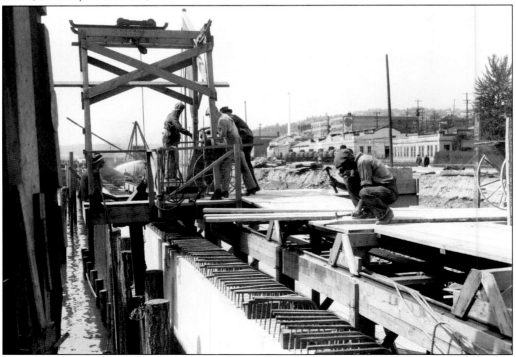

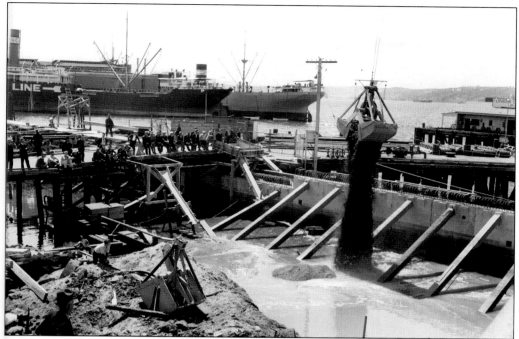

FILLING BEHIND THE NEW SEAWALL. Above, a clamshell shovel is used to place fill behind the newly constructed seawall at Bay Street and Railroad Avenue in June 1934. Below, workers seal the seawall with a concrete lid for automobile and pedestrian traffic around 1934. (Above, courtesy SMA-8919; below, courtesy SMA-9012.)

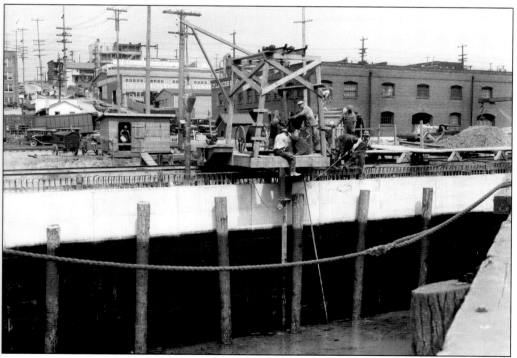

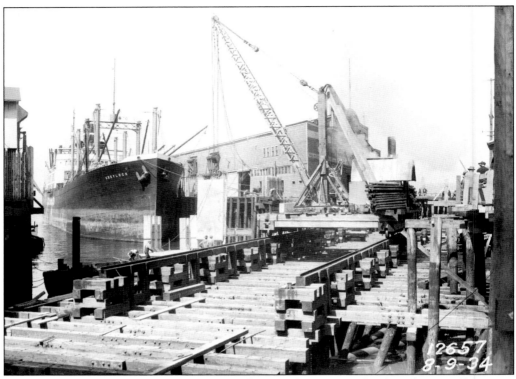

LAYING SEAWALL SLAB, 1934. These images illustrate the process of sealing the seawall (putting a lid on the seawall for use as a road, sidewalk, or structural foundation). The above image was taken along Railroad Avenue south of Pier 14 (now Pier 70). This work continued alongside the daily functions of the port, as demonstrated by the ship docked at Pier 14. Below, the sealing process is shown at Railroad Avenue and Vine Street. (Above, courtesy SMA-9035; below, courtesy SMA-9250.)

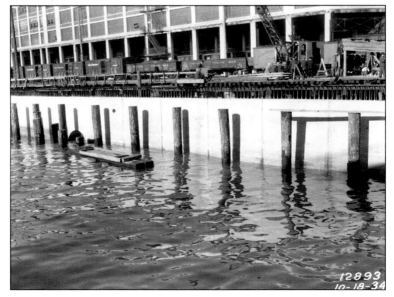

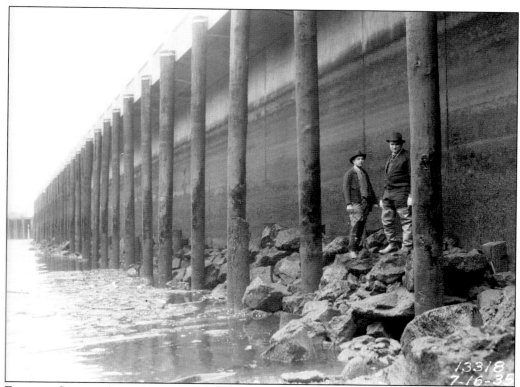

EXTERIOR SEAWALL (ABOVE) AND SHATTERED PILING (BELOW), 1935. Regardless of the construction method, material, or project, unexpected conditions or challenges will eventually arise. Above is an exterior view of the seawall north of Broad Street. The two men standing next to the pilings during low tide illustrate the height of the seawall; the high-tide line is visible on the seawall. The below image illustrates the challenges of pile-driving. These pulled pilings have shattered ends, which potentially impact the overall structural integrity. The natural aquatic environment had been drastically changed as a result of the seawall. Although Native Americans were aware of the delicate balance of the ecosystem for centuries, the engineers and construction workers of the 1930s gave little thought to habitability issues. (Above, courtesy SMA-9756; below, courtesy SMA9530.)

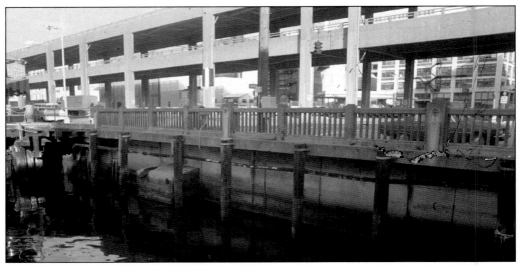

CONCRETE PIERS AND VOIDING. Above is a 1935 image of concrete piers under the sealed seawall along Railroad Avenue, near the American Can Company Dock located at what is now Pier 69 (Port of Seattle headquarters). Below is a 1954 image of a void under Alaskan Way where the filled area had been eroded, most likely from tidal action behind the seawall. This type of problem, combined with wood-eating organisms like teredos and gribbles, adds to the risk of structural integrity issues with structures exposed to harsh marine environments. (Above, courtesy SMA-13317; below, courtesy SMA-18461.)

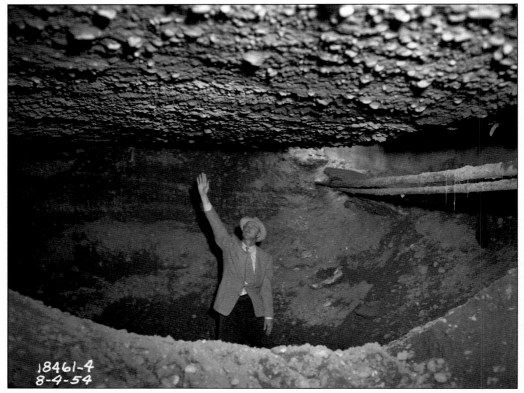

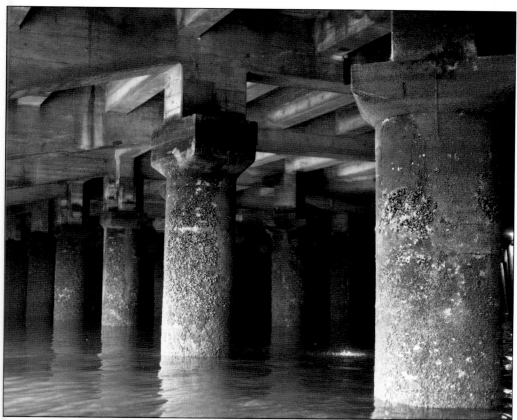

ALASKAN WAY VIADUCT AND SEAWALL. The 1973 image above shows the Alaskan Way Viaduct and Seattle's seawall, demonstrating the connectivity of the two structures in terms of proximity and dependency. If the seawall were to fail, the Alaskan Way Viaduct would be at a high risk of failure. Conversely, if the Alaskan Way Viaduct were to fail, it would most likely cause the seawall to fail, too. After the 2001 Nisqually earthquake, city and state transportation engineers indicated that there was a one-in-ten risk that both the seawall and the viaduct would fail in a seismic event within the next 10 years. Below is an artist's rendition of what the waterfront would look like if neither of these structures are fixed before a seismic event occurs. Seattle is holding its collective breath as it struggles with construction challenges and scheduling issues to repair these structures. (Above, courtesy SMA-76049; below, courtesy SMA-8821.)

PROPOSITION NO. 1. Seattle voted several times on issues relating to both the seawall and the replacement options for the Alaskan Way Viaduct. In November 2012, Proposition No. 1 was added to the ballot, requesting Seattleites to approve an excess property tax to pay for the $290 million required to design, construct, renovate, improve, and replace the Alaskan Way Seawall and associated public facilities and infrastructure. Without a "yes" on this proposition, the repair of the seawall could not move ahead, putting the public safety and economic health of the region at risk in case of catastrophic seismic activity. In November 2012, voters overwhelmingly supported the proposal, with 77 percent voting for approval of the proposition. (Left, courtesy of the author; below, courtesy *Seattle Times*.)

Bond to repair seawall passing

LOCAL ISSUES

BY LYNN THOMPSON
Seattle Times staff reporter

With images of severe storm and flood damage from the East Coast fresh in many voters' minds, Seattle residents overwhelmingly approved a $290 million, 30-year bond measure to reconstruct the aging Elliott Bay seawall.

In Tuesday's initial vote count, 77 percent of voters were supporting the seawall replacement and just 23 percent were voting to reject it.

"It's astonishing," said Seattle City Councilmember Tom Rasmussen. "The voters have spoken so strongly to protect our infrastructure, to move forward with rebuilding the waterfront, to keep traffic moving. It's a great investment for the next 100 years."

King County voters, meanwhile, approved a six-year renewal of a levy for a $119 million automated fingerprint system to assist law enforcement in gathering and processing crime-scene evidence. Fifty-nine percent of voters approved the levy.

"This is a very important tool that we use every day in crime fighting," said King County Prosecutor Dan Satterberg. "I know some people wish it could be funded in the general fund, but the special levy funding has protected the program from the kind of cuts other criminal-justice programs have taken over the past five years."

The two measures will increase property taxes for the median $360,000 home in Seattle about $68 per year.

Proponents of the seawall measure argued that the largely wooden barrier, constructed between 1919 and 1936, was never designed to withstand a major earthquake and was badly damaged by gribbles and tidal action. City leaders said that failure of the wall could cause much of Alaskan Way to collapse, threatening transportation routes and major utility lines.

They also had a timeline to meet. Removal of the Highway 99 viaduct, damaged in the 2001 Nisqually earthquake, and the planned reconstruction of Alaskan Way in its place, can't be completed until the seawall is rebuilt.

There was no organized opposition to the measure, but some opponents said that the whole city shouldn't be taxed for infrastructure that would primarily benefit waterfront property owners. The Automated Fingerprint Identification System is used by all of King County's cities and unincorporated areas. Satterberg and the entire Metropolitan King County Council supported the levy renewal.

An estimated $1.5 million of the levy funds would be spent to replace the fingerprint-processing lab, which the county has outgrown.

The levy also had no organized opposition, although some residents complained that property taxes have continued to increase while many incomes remain flat.

Prop. 1 results

Alaskan Way
Seawall funding,
as of 8:15 p.m.
Tuesday

Yes

77%

No

23%

Information from The Seattle Times archives is included in this report.
Lynn Thompson: 206-464-8305 or lthompson@seattletimes.com. On Twitter @lthompsontimes.

Context of the Seawall Project

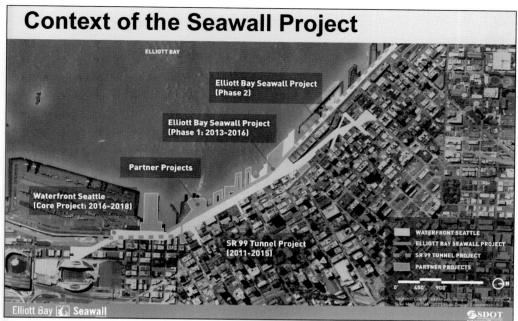

THE HABITAT-FRIENDLY SEAWALL OF THE FUTURE. The November 2012 public vote on Proposition No. 1 gave city planners and engineers approval to move forward with visioning, concept, design, and construction of the Alaskan Way Seawall. The schedule they developed projected seawall construction to be completed by 2020. An Environmental Impact Statement required by Washington's State Environmental Policy Act (SEPA) was completed in 2014. The above image shows the proposed location where the seawall will be replaced along Seattle's Central Waterfront, from South Washington Street north to Virginia Street. The below image shows a cross section of the seawall construction methodology. Habitat enhancement and sustainability are working objectives for the new seawall to help improve ecosystem damage that occurred as a result of prior projects. Habitat improvements include environmentally friendly texture and the design of seawall structure itself to support a healthy aquatic ecosystem. (Both, courtesy City of Seattle.)

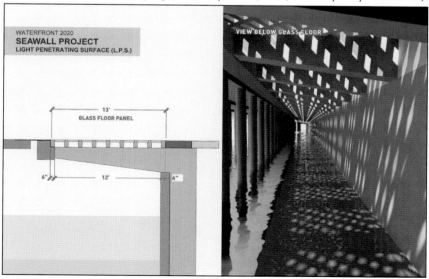

FUTURE HABITAT BEACH (ABOVE) AND SALMON MIGRATION (BELOW). The habitat beach proposed between Yelser and Washington Streets will form a critical piece of the ecosystem improvements and help reconnect people to the shoreline. Light-penetrating surfaces will be placed in the cantilevered sidewalk to form a migration corridor for juvenile salmon traveling from the Duwamish River through Elliott Bay. (Both, courtesy City of Seattle.)

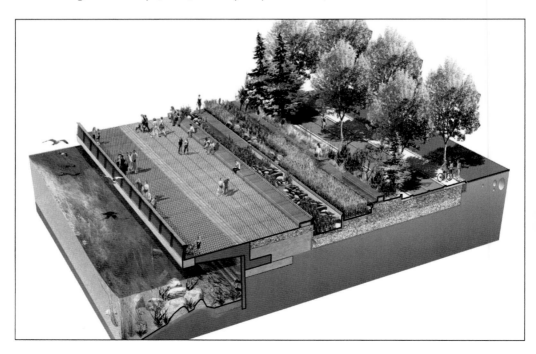

Seven

ALASKAN WAY VIADUCT

The gridlocked streets of Seattle hampered the economic growth and the movement of goods and people from the working waterfront to their ultimate destinations. The idea of an elevated structure to bypass the congested downtown streets began to emerge in the 1920s. The City of Seattle and the Washington State Department of Transportation partnered together over two decades, in the 1930s and 1940s, to plan and design the proposed elevated structure. February 6, 1950, marked the beginning of construction for the Alaskan Way Viaduct, a double-decker reinforced-concrete structure providing northbound and southbound traffic infrastructure along the shoreline of Elliott Bay. The construction phase took 16 years to complete and opened to the public in phases from 1953 to 1966. It was not until the viaduct was built that many people fully realized its magnitude and impact on the waterfront in terms of noise, visibility, and ambience. The Alaskan Way Viaduct served as a major transportation corridor along State Route 99 for nearly 60 years, with nearly 110,000 vehicle trips per day in 2001.

With a magnitude of 6.8, the 2001 Nisqually earthquake weakened the already aging structure. Federal, state, and local engineers identified the urgent need to repair or replace both the seawall and the viaduct before there was a catastrophic failure. The need to replace the seawall and viaduct was identified in the 1990s, but the earthquake created the urgency to begin significant planning for the replacement of both the seawall and the viaduct, leading to more than a decade of debate about how to replace the existing structures. In 2009, after examining over 90 different options, leaders from the City of Seattle, King County, Washington State Department of Transportation, and the Port of Seattle agreed to a bored-tunnel solution. Removal of the southern portion of the viaduct began in 2011. It is projected that the tunnel will be completed and open to traffic in 2018; the 1950s-era viaduct is projected to be removed by 2016 or 2017. After Seattle's waterfront was choked with railways, docks, and warehouses—and later dominated by the massive double-decker concrete viaduct—it is anticipated that, by 2020, Seattle will once again have a strong connection to its waterfront.

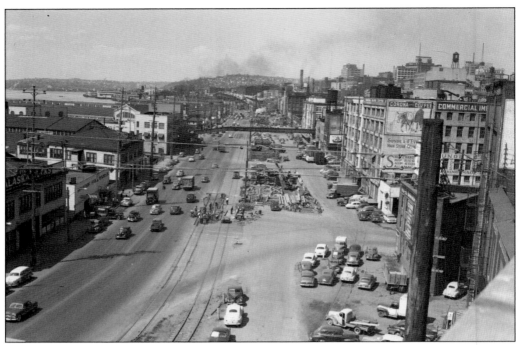

BEFORE (1940s) AND AFTER (1950s). Initially hailed as the long-term solution to Seattle's traffic woes, the Alaskan Way Viaduct presented a multitude of unintended consequences once it opened along the waterfront in 1953—visual impairment of east-west view corridors, and east-west barrier to commercial establishments, poor access off the viaduct to downtown and the waterfront, and noise and air pollution. These two images show aerial views of Seattle's waterfront before and after the completion of the Alaskan Way Viaduct. (Above, courtesy SMA-43130; below, courtesy SPL-shp-20786.)

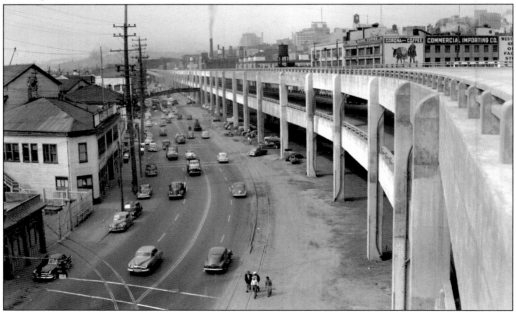

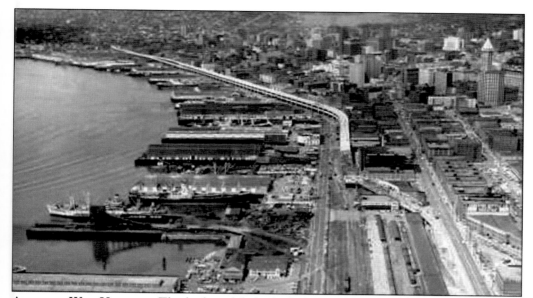

ALASKAN WAY VIADUCT. The look and feel of Alaskan Way (previously Railroad Avenue) changed dramatically when the Alaskan Way Viaduct was completed. The above image looks south to Alaskan Way from Pike Street in November 1951. The below image, taken around 1952 from Colman Dock looking north, shows Alaskan Way, the Alaskan Way Viaduct, and buildings along the waterfront. The massive structure dominated the landscape visually, aesthetically, and acoustically, and also had economic impacts. (Above, courtesy SMA-43521; below, courtesy SMA-43599.)

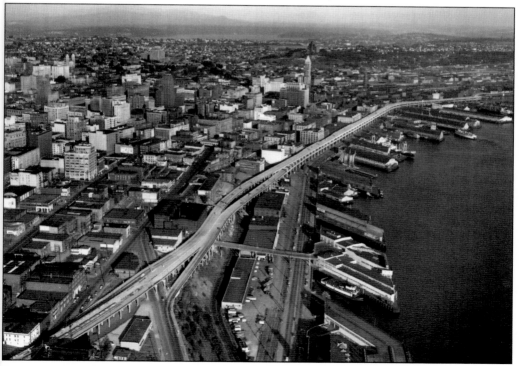

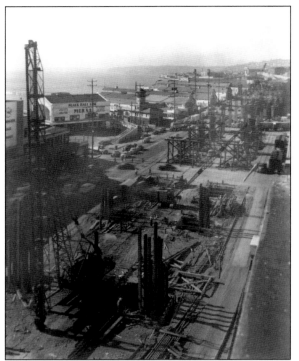

CONSTRUCTION OF ALASKAN WAY VIADUCT. The construction of the Alaskan Way Viaduct was a massive undertaking. What was once natural shoreline with water 20 feet deep in Elliott Bay had been converted to a 120-foot-wide elevated road that held over 12 different railway lines in the 1890s. Railroad Avenue was converted back to Alaskan Way in the 1930s and was dramatically transformed yet again with the Alaskan Way Viaduct in the 1950s. These images show the construction progress over time. The 1951 image at left offers an aerial view of the width of the project and the complexity of building the viaduct over former tidal lands. The below image depicts what workers experienced during construction. (Left, courtesy TPL-2621; below, courtesy SMA.)

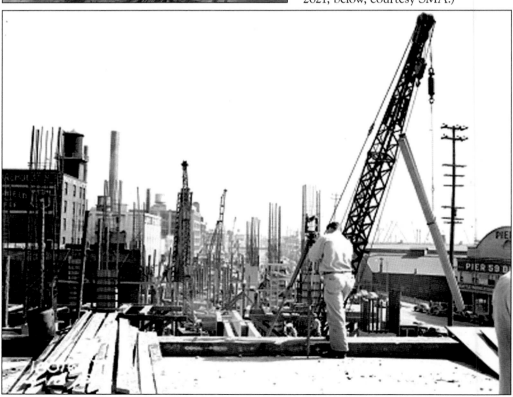

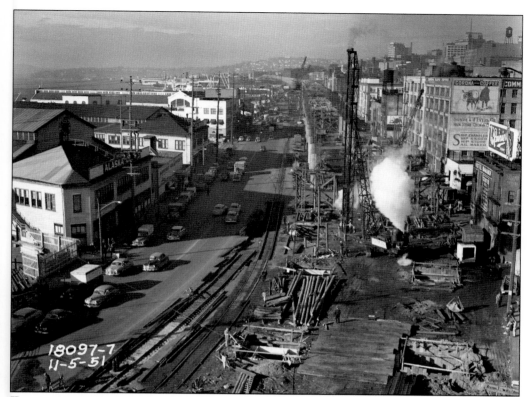

TRANSFORMING ALASKAN WAY INTO ALASKAN WAY VIADUCT, NOVEMBER 1951. Construction of the Alaskan Way Viaduct spanned a decade, hurting businesses located on Alaskan Way. Seattle's waterfront area was still predominately commercial and industrial and had not yet transformed into the tourist destination it is today. These images illustrate how the old railroad right-of-way and loading docks/parking area to the west of Western Avenue were being transformed for automobiles—both at street level along Alaskan Way and via the elevated transportation structure under construction. Covered parking under the viaduct was touted as a benefit for both businesses and the public, who endured many days of drizzle in the rainy city. (Above, courtesy SMA-43509; below, courtesy SMA-43501-18097.)

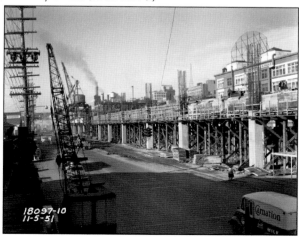

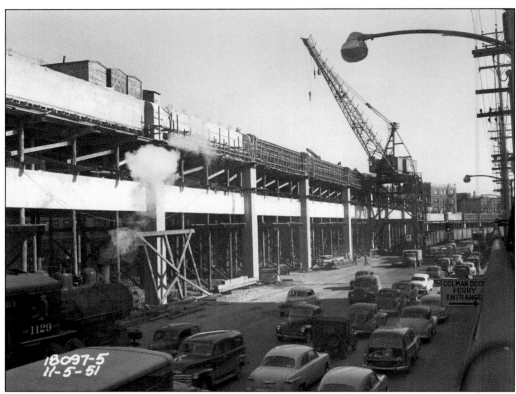

ALASKAN WAY VIADUCT FROM COLMAN DOCK, NOVEMBER 1951 (ABOVE) AND JULY 1952 (BELOW). Looking south along Alaskan Way near Colman Dock, these images document the progress of the Alaskan Way Viaduct. The above image provides a view of the construction status at the time, as well as traffic congestion along Alaskan Way. The below image shows the same location eight months later. (Above, courtesy SMA-43508; below, courtesy SMA-43538.)

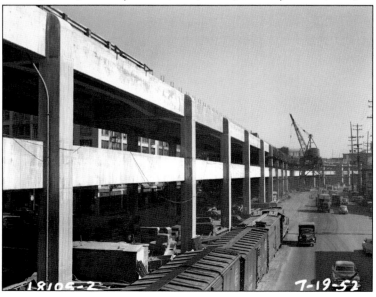

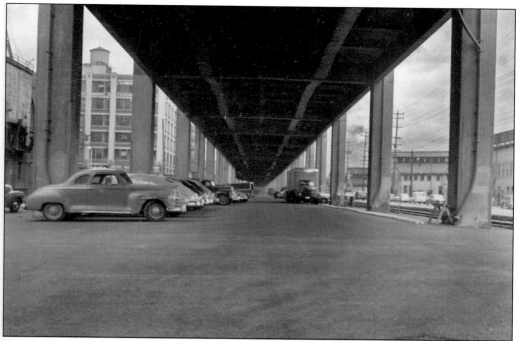

BELOW AND BESIDE ALASKAN WAY VIADUCT. These two images, taken in August 1952 (above) and March 1953 (below), illustrate what is looked like under the Alaskan Way Viaduct once it was complete. Covered parking was a benefit for businesses and customers. The below image, which looks west from Yesler Way near the location of Henry Yesler's original steam-powered sawmill, illustrates how the Alaskan Way Viaduct blocked the view of the waterfront. (Above, courtesy SMA-43590; below, courtesy SMA-66884.)

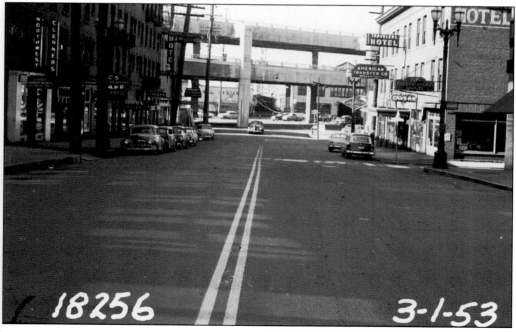

ACOUSTIC AND VISUAL IMPACTS. Due to the lack of required analysis or disclosure of environmental impacts in the 1950s, most of the building owners and tenants along the east side of the Alaskan Way right-of-way were not expecting nor fully prepared for the acoustic and visual impacts they experienced when the Alaskan Way Viaduct was completed and became operational. The view of Elliott Bay and the piers along the waterfront had been transformed into a hunk of concrete with continuous noise levels of 85 decibels. The noise not only affected the occupants of the buildings but also the pedestrians who used the space. (Above, courtesy of the author; below, courtesy SMA-76049.)

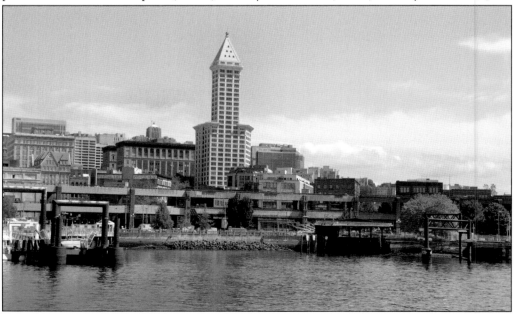

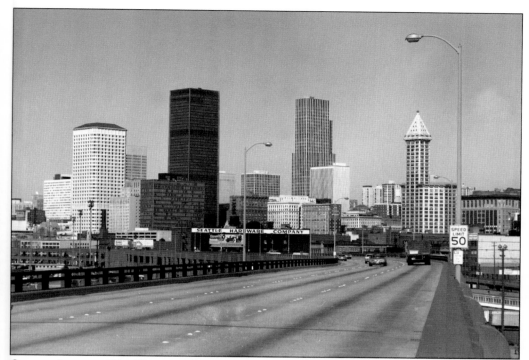

ON THE ALASKAN WAY VIADUCT. Of course, there were benefits associated with the Alaskan Way Viaduct. North-south traffic flowed through the city significantly better than it had before. The views from the northbound upper deck of the viaduct were spectacular. Covered parking, which was an added benefit of the viaduct, is always a plus in rainy Seattle. The above image, taken from the upper northbound deck of the viaduct in 1975, shows the view of the city skyline from the viaduct. The below image, taken from the upper deck of the viaduct in 1969, shows the view of Seattle's waterfront. (Above, courtesy SMA-73017; below, courtesy MOHAI-1986.5.51048.1.)

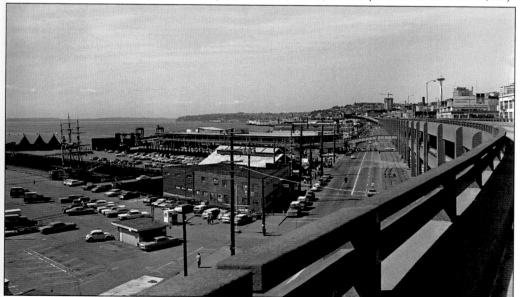

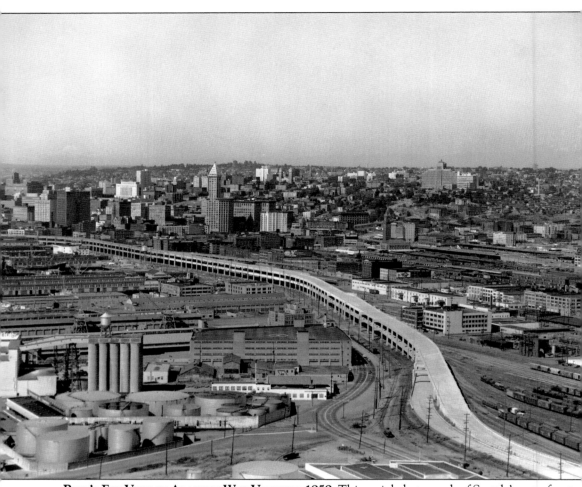

BIRD'S-EYE VIEW OF ALASKAN WAY VIADUCT, 1959. This aerial photograph of Seattle's waterfront clearly documents how the landscape changed with the 2.1-mile Alaskan Way Viaduct. This image looks northbound from Harbor Island. (Courtesy MOHAI-1986.5.12223.)

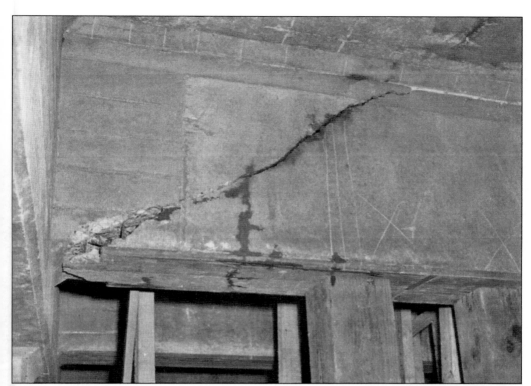

EARTHQUAKE. Although it was not known at the time of construction, the Alaskan Way Viaduct (SR 99) crosses the Seattle Fault—a region with high risk of seismic activity. Additionally, much of the Alaskan Way Viaduct is built on fill, which is prone to liquefaction in a seismic event. The Alaskan Way Viaduct has withstood two significant earthquakes yet sustained damage in each that had to be repaired in order for the viaduct to remain open. The above image shows cracks sustained in the 1962 earthquake. At right, workers repair damage to the columns after the 2001 Nisqually earthquake. Since 2001, the Washington State Department of Transportation has invested $14.5 million in repairs to keep traffic moving on SR 99 and to install barriers to close access to the viaduct during an earthquake. (Above, courtesy SMA 69882; right, courtesy WSDOT.)

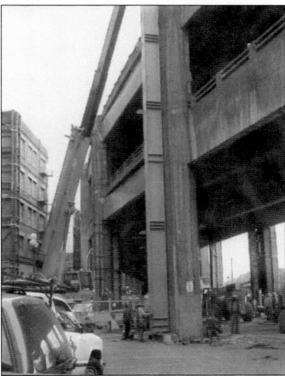

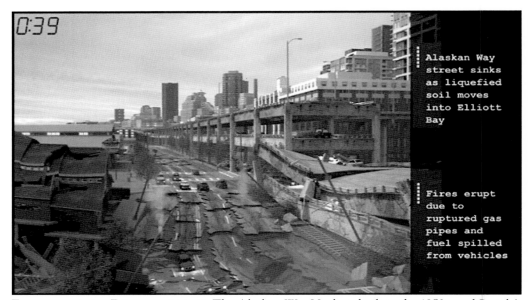

0:39

Alaskan Way street sinks as liquefied soil moves into Elliott Bay

Fires erupt due to ruptured gas pipes and fuel spilled from vehicles

EARTHQUAKE AND DECONSTRUCTION. The Alaskan Way Viaduct, built in the 1950s, and Seattle's seawall, built in the 1930s, were reaching the end of their design life when the 2001 Nisqually earthquake hit, weighing in at 6.8 on the Richter scale. This was a wake-up call to federal, state, and city transportation departments; elected officials; the Port of Seattle; and the public about the real risk of catastrophic failure for these two critical components of infrastructure supporting Seattle's economy, commerce, and quality of life. The above image is an artist's rendition illustrating the potential impacts to Seattle's waterfront should a seismic event take place that causes both the seawall and the Alaskan Way Viaduct structures to fail. Below is a photograph of a portion of the Alaskan Way Viaduct being torn down in 2013. (Both, courtesy WSDOT.)

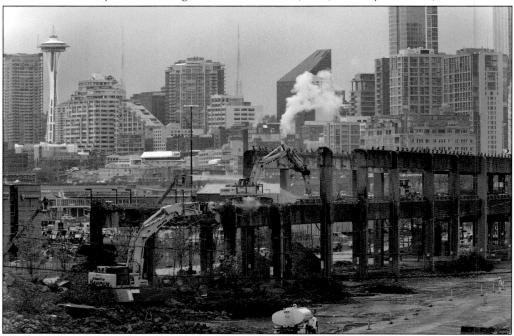

Eight

WORLD'S LARGEST BORED TUNNEL

There has never really been any debate that both the seawall and the Alaskan Way Viaduct were at risk of failure in a seismic event—it was not an "if" but a "when" question—and most everyone accepted this. The controversy had to do with "what to build," "how to pay," and "who pays," especially when the initial price-tags emerged. After nearly 10 years of public input, political process, and significant controversy, federal, state and local governments reached a consensus in 2009 to build a bored tunnel to replace the Alaskan Way Viaduct. In December 2010, WSDOT awarded a design-build contract for construction of a deep bored tunnel to Seattle Tunnel Partners (STP). In August 2011, Seattle voters overwhelmingly endorsed the state's plan to build a tunnel to replace the Alaskan Way Viaduct, approving Referendum No. 1 (which regarded a city-state agreement related to construction of the city's share of the $2.3 billion deep-bored tunnel replacement) by a margin of nearly 60 percent. The first 1,500 feet of the tunnel will be under Alaskan Way and Seattle's original shoreline.

Bertha, the world's largest tunnel boring machine, is 57.5 feet (roughly 6 stories) tall and arrived in Seattle in April 2013. Named after Seattle's first and only female mayor, Bertha Knight Landes, the machine began its 9,270 foot (1.8 mile) trip under Seattle in October 2013, only to be stopped by a labor dispute after 24 feet of progress. Bertha restarted the trip in December 2013, and after progressing 1,000 feet, became stuck 60 feet below the original shoreline. This time, officials announced a nine-month delay (later revised to a 16-month delay) due to a problem in the drive unit protecting the main bearing that required replacement.

Once Bertha completes the journey from Seattle's Pioneer Square Stadiums to the Gates Foundation, Seattle will have the largest-diameter bored tunnel in the world. The cost of the tunnel project is projected to be around $2.3 billion, paid with funds provided by federal, state, and Port of Seattle sources. This cost includes removal of the viaduct, decommissioning the Battery Street Tunnel, and replacement of Alaskan Way from King Street to Elliott Way and Western Avenue. Other improvements to the waterfront will be paid for by a combination of city, Local Improvement District, and private sources. Once the tunnel is completed (the projected completion date is 2017), it will allow for the removal of the viaduct, and Seattle can implement its future vision for the waterfront.

'ALRIGHT, YOUS GUYS, HERE'S THE PLANS THE STATE JUST SPENT $915 MILLION ON.'

DECISIONS AND CONTROVERSIES. The city and state considered more than 90 different design concepts for the replacement of the viaduct and seawall, including repairing the structure, rebuilding an elevated structure, building a bridge over Elliott Bay, or constructing a cut-and-cover tunnel. In 2004, Washington governor Gary Locke and Seattle mayor Greg Nickels agreed to build a cut-and-cover-tunnel along the waterfront with a new seawall that would serve a dual purpose as the west side of the tunnel. In 2007, a projected cost estimate of $3.6 to $4.3 billion, along with concerns voiced by waterfront businesses and regulators of state/federal safety standards, caused new governor Christine Gregoire to reject the cut-and-cover-tunnel solution. A public-advisory vote was held in 2007 to determine whether the Alaskan Way Viaduct should be replaced with an elevated structure or a tunnel. The public rejected both options, offering little guidance to elected officials. Finally, in 2009, Governor Gregoire, Mayor Nickels, King County Executive Ron Sims, and the Port of Seattle agreed to a deep-bored tunnel solution that would require the city to independently fix the seawall. (Above, courtesy Terrence Nowicki Jr.; below, courtesy Milt Priggee—www.miltpriggee.com.)

PUBLIC SAYS MOVE AHEAD. The above image shows Seattle mayor Greg Nickels (left), Washington governor Christine Gregoire (center), and King County Executive Ron Sims (right), signing agreements relating to the bored tunnel solution in October 2009. "This is an historic day for Seattle," Nickels said. "We finally connect our city to Puget Sound and ensure that people and freight move swiftly and safely. Generations to come will reap the benefits of this agreement." Advocating for a surface-transit concept, Mayor Mike McGinn came into office in January 2010 and promptly vowed to veto tunnel ordinances and agreements if the Washington State Department of Transportation did not agree to cover cost overruns. According to a *Seattle Times* report from August 16, 2011, "the City Council approved the agreements 8-1 over McGinn's veto. Not giving up, tunnel opponents collected enough signatures—28,929 in a month—to force a public vote." The results of the 2012 vote were not what McGinn had hoped for. After the vote, newspaper headlines read, "McGinn: 'Public said move ahead . . . and that's what we're going to do.'" (Above, courtesy WSDOT; below, courtesy *Seattle Times*.)

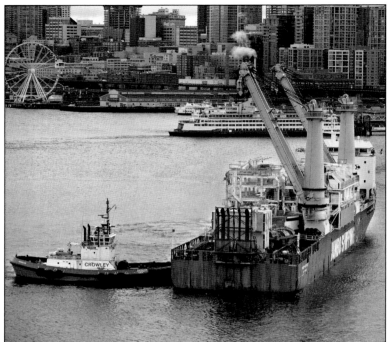

BERTHA ARRIVES FROM JAPAN. The world's widest boring machine arrived in Seattle on April 1, 2013, from Osaka, Japan, where it was built in one year for $80 million. The machine will bore a two-mile-long tunnel under Seattle, following Seattle's original shoreline. With an overall length of 300 feet, the boring machine is roughly the size of a large ferry, and with a diameter of 57 feet, the cutterhead is nearly five stories tall. (Courtesy WSDOT.)

BORING MACHINE CONTROL STATION. A glimpse inside the boring machine shows the complexity of instrumentation needed to guide the machine deep under Seattle. The Washington State Department of Transportation entered into a design-build contract with a consortium, Seattle Tunnel Partners, to build a deep-bored tunnel to replace the Alaskan Way Viaduct. It is estimated that about 25 crew members will be working in the machine at any given time. (Courtesy WSDOT.)

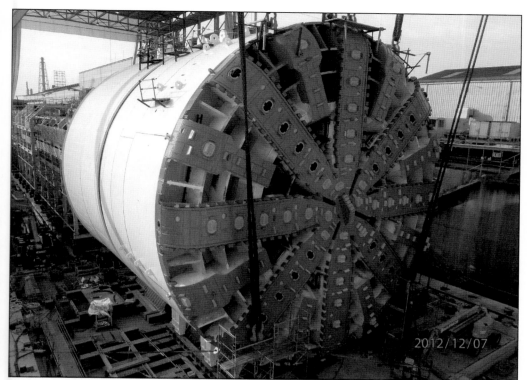

BERTHA. In the above image, the tunnel-boring machine, Bertha, prepares to begin its journey under Seattle and back again. Bertha weighs nearly 7,000 tons, is 326 feet long, has a diameter of 57 feet, and stands nearly 5 stories tall. The machine will bore two miles under Seattle for the new tunnel and will help redefine Seattle's waterfront. At right is Mayor Bertha Knight Landes, the namesake of the machine. Landes was elected in 1926 and served for one term. The Seattle City Council approved the name "Bertha" after a naming contest in which two entrants submitted the winning name: Darryl Elves' fifth-grade class at Poulsbo Elementary School and Elijah Beerbower, a second-grader at Lincoln Elementary in Hoquiam. Both classes received free fish and chips from Ivar's for their submissions. (Above, courtesy WSDOT; right, courtesy SPL-shp-15126.)

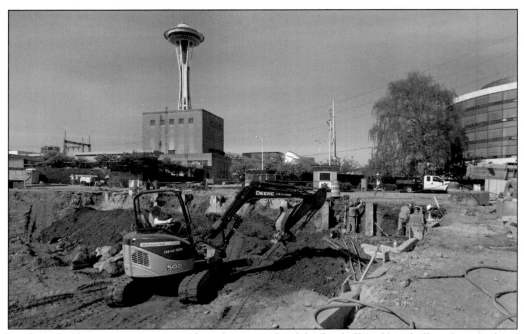

LET'S DIG. Above, a pit is excavated on the west side of the football and baseball stadiums, where tunnel boring began on July 30, 2013. Bertha was reassembled here after the machine's voyage from Osaka, Japan. This launch pit will eventually be the entrance to the new tunnel. The pit dimensions—80 feet wide by 400 feet long by 80 feet deep—will hold the boring machine, the tunnel operations building, and other required support systems. The first portion of the tunneling will take place in Seattle's historic Pioneer Square, initially following the original waterfront shoreline. The pit is located near the former site of the Moran Brothers Company shipbuilding yard in the late 1890s (see pages 41 and 64). (Both, courtesy WSDOT.)

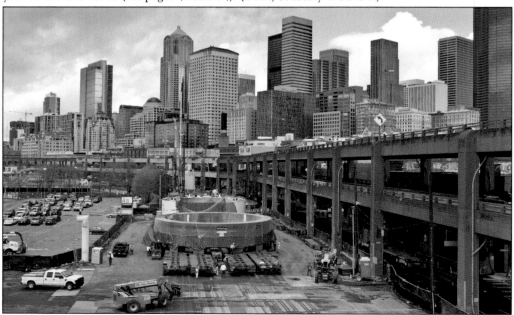

DEDICATION CEREMONY. Former Washington governor Christine Gregoire (left) and current governor Jay Inslee are pictured at the "Big Bertha Dedication Ceremony," which was held in the launch pit (the site of the future entrance to the new tunnel). (Courtesy WSDOT.)

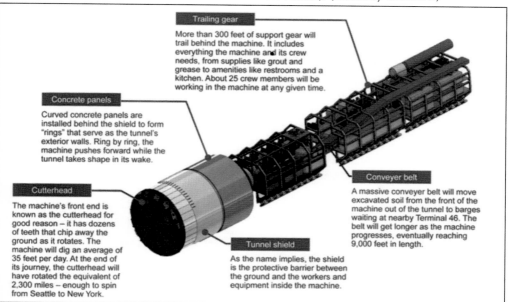

BORING MACHINE SCHEMATIC. The cutterhead has 260 teeth that chip away at the ground as the face rotates. The tunnel shield is the protective barrier between the ground, workers, and equipment inside the machine. Curved concrete panels installed behind the shield will form rings that will become the tunnel's exterior walls. A massive conveyor belt, which will lengthen as the machine progresses, moves excavated soil to barges outside the tunnel. The trailing gear is a compartment that houses everything the machine and crew needs. (Courtesy WSDOT.)

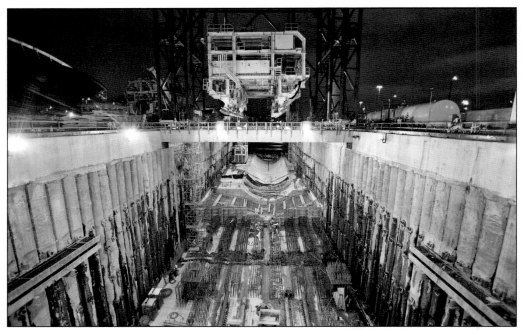

BORING LAUNCH PIT. In the above image, concrete cylinder piles line the newly constructed launch pit, located in Pioneer Square just west of the stadiums. The overhead crane system is used to move heavy equipment in and out, including the lowering of Bertha into the pit. It was projected that once Bertha began its 1.8-mile journey under the streets of Seattle, it would bore up to 35 feet per day. As Bertha progresses, it will install precast rings to form the tunnel; each ring is composed of 10 precast segments. Below, a worker stands in the interior of the section of the tunnel that has been completed (with the precast rings installed). (Both, courtesy WSDOT.)

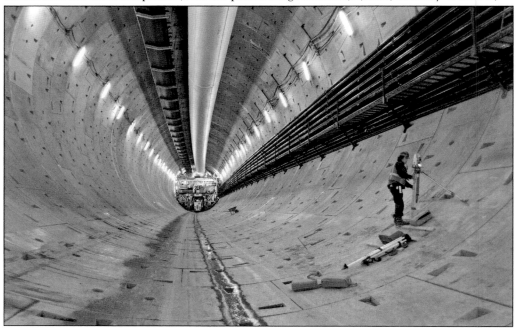

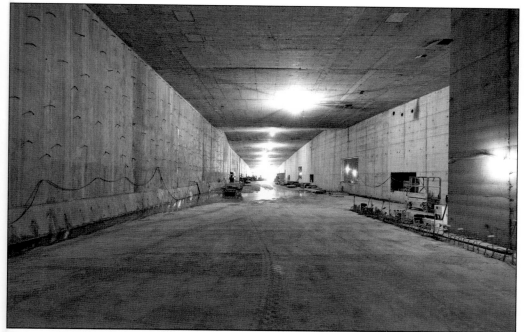

Viaduct Foundation and Portal Construction. In the above image, workers are preparing the interior of the boring launch pit for Bertha. Below is a schematic drawing that illustrates the tunnel route under the existing Alaskan Way Viaduct. The viaduct has been strengthened so that when the boring machine tunnels underneath it, there will be no impact on the integrity or function of the Alaskan Way Viaduct, which will remain in use until the new tunnel is open. Using a series of steel tubes drilled into the ground, 22 underground walls were constructed at an angle . The angled walls are designed to hold the soil in place underneath the viaduct by creating a barrier between the boring machine and the viaduct's foundation. (Both, courtesy WSDOT.)

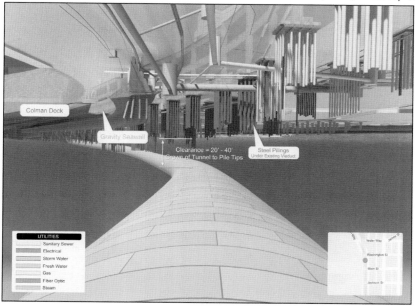

DEBRIS AND UNION DISPUTE HALT BERTHA. On July 30, 2013, Bertha began its journey under Seattle to build the world's largest-diameter bored tunnel. The machine bored 24 feet before being slowed first by a clog in the cutterhead, then by a labor dispute that halted work on August 20, 2013; work was delayed for approximately one month. After restarting, Bertha traveled nearly 1,146 feet before it was stopped again on December 2013 by a mysterious object (pictured above) that was initially reported as debris. Local historians speculated that Bertha may have hit a sunken ship or locomotive or some other relic from Seattle's past. After further studies, engineers indicated that the cause of the blockage may have been a steel pipe that was used for geotechnical boring samples but never removed. Further analysis indicated that the problem was not debris; it was the seals of Bertha's cutterhead causing overheating. (Above, courtesy WSDOT; below, ILWU.)

Alaskan Way Viaduct Replacement
Program Expert Review Panel
Updated Report

February 27, 2014

Schedule

- The Project's completion date will probably be delayed. Time lost by the current tunnel stoppage can be partly mitigated by opportunities that have been identified by STP to gain back some schedule time. Based on the ERP's review, it appears that the tunnel will open in the first or second quarter of 2016, which is later than STP's proposed contract date of December 31, 2015, but earlier than the contract performance date of November 13, 2016.

- Given the commencement of the City of Seattle's ("City") Seawall project in the vicinity of STP's current work, contractor coordination and traffic management could have potential schedule or cost impacts to the State, the City and/or STP if not closely monitored.

The TBM is no longer moving forward, and tunnel progress stopped on December 6, 2013. Even with several well-publicized delays prior to this (later than anticipated start of tunneling and labor disputes) the progress of the TBM was significantly better than anticipated. At the time of the stoppage, and despite these delays, the TBM was only two feet away from its originally scheduled location on this date.

The ERP finds that the most important schedule-related risk item for the Project is with regard to effective partnership between WSDOT and STP: the entire WSDOT AWV Project Team must work in collaboration with STP and other stakeholders to get the TBM moving and progress tunnel excavation. To this end several parallel efforts have been initiated. An investigation is ongoing and multiple reports and task forces from WSDOT, STP and Hitachi-Zosen (the TBM manufacturer) that will clarify the cause or causes for the TBM stoppage as well as the proposed means and methods for fixing the TBM so it can proceed with tunneling. The ERP has confidence that the issue will be resolved and that the tunnel operation will proceed promptly upon this resolution.

Given the process being undertaken to fix the TBM and problems identified to date, it should be anticipated that a feasible window to re-start tunneling is between June and October 2014. This could result in an overall delay of seven to ten months to STP's proposed contractual date of December 31, 2015. It should be noted that additional issues or problems found during the ongoing investigation could increase the time of repair.

EXPERT REVIEW PANEL (ERP) FINDINGS. The report pictured above says: "The Project's completion date will probably be delayed . . . opening in the first or second quarter of 2016." The report goes on to state, "Given the commencement of the City of Seattle's Seawall project in the vicinity of STP [Seattle Tunnel Partners]'s current work, contractor coordination and traffic management could have potential schedule or cost impacts to the State, the City and/or STP if not closely monitored." The report goes on to state that, "the ERP finds that the most important schedule-related risk item for the Project is with regard to effective partnership between WSDOT and STP; the entire WSDOT AWV Project Team must work in collaboration with STP and other stakeholders to get the TBM [tunnel boring machine] moving and progress tunnel excavation." This March 2014 headline from the *Seattle Times* confirms that cost continues to be an issue. (Above, courtesy WSDOT; right, courtesy *Seattle Times*.)

DIGGING IN
COST TO FIX BERTHA MAY TOP $125M, BUT WHO WILL PAY?

FIRST PUBLIC GLIMPSE AT REPAIR COSTS

Battle over blame may take years, go to court

By MIKE LINDBLOM
Seattle Times transportation reporter

Highway 99 contractors said Tuesday they expect the costs to repair and restart tunnel machine Bertha to reach at least $125 million.

Chris Dixon, project director for Seattle Tunnel Partners (STP), mentioned the figure during a briefing Tuesday to The Seattle Times' Editorial Board, which is responsible for writing and choosing opinion pieces.

However, the $125 million isn't a hard figure, and who will pay is yet to be determined.

That amount is 1½ times the $80 million STP paid for the machine, completed in 2012 by Hitachi Zosen in Osaka, Japan.

Dixon said the $125 million was based on restarting Bertha by Sept. 1, which was STP's earlier, optimistic goal.

The restart has been delayed until March 2015, and he said it fair to assume costs would therefore increase.

This is the first time contractors or the state have publicly offered a glimpse of the costs

121

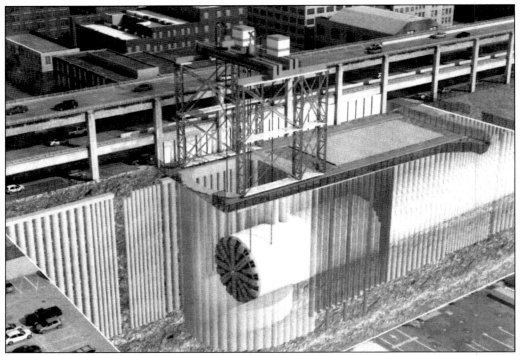

PROPOSED RESCUE PLAN. On April 21, 2014, Seattle Tunnel Partners (STP) released a conceptual approach regarding how STP plans to rescue Bertha. In December 2013, Bertha became stuck 60 feet underground, between Jackson Street and Main Street, directly underneath the Alaskan Way Viaduct. The plan is to dig a vertical pit in front of the tunneling machine. While excavating the rescue pit in October 2014, STP discovered a shell midden, requiring consultation with local tribes for archeological reconnaissance, which could further delay the project. Once the pit is completed, the tunnel machine will move into the pit and Bertha's main drive will be removed, repaired, and replaced. The *Seattle Times* reported that the estimated repair may cost $125 million dollars and that digging will resume in March 2015, pushing the projected completion date from 2016 to 2017. This delay impacts the demolition of the AWV and the redevelopment of Seattle's waterfront, as both projects are dependent upon the completion of the tunnel. The question of who will pay for cost overruns continues to be part of the controversy. (Courtesy STP.)

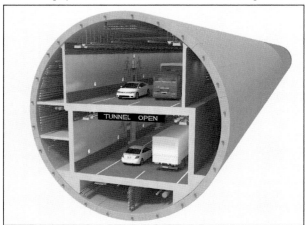

DOUBLE-DECKER TUNNEL DESIGN. Seattle's deep-bored tunnel is a very complex project. In fact, it is one of the most significant and complex projects ever undertaken by the city and state. It is important to keep the end result in mind—an underground, double-decker tunnel that can support over 100,000 vehicles per day. The new tunnel will help alleviate traffic congestion and conflict with rail operation; it will also allow the city of Seattle to redevelop the waterfront for future generations. (Courtesy WSDOT.)

Nine

VISIONS OF 2020 AND BEYOND

The imminent replacement of the Elliott Bay seawall and removal of the Alaskan Way Viaduct present a once-in-a-lifetime opportunity to turn visions into reality and create a vibrant public space that will reconnect the city and its people to the waterfront. In 2010, Seattle began an extensive process to create a future vision of Seattle's central waterfront. With a new surface street, improved east-west connections, and improved access to the waterfront, the vision for Seattle's central waterfront will extend into the heart of the city and claim a new and authentic "front porch" on Elliott Bay. In 2013, the City of Seattle released a planning and design document entitled "Waterfront Seattle" that represents the first 21 months of conceptual work. Extensive outreach efforts were implemented to engage civic groups, property owners, stakeholders, and relevant government agencies in creating a future vision of Seattle's waterfront.

A broad spectrum of input from diverse parties resulted in the development of the following guiding principles:

1) creating a waterfront for all
2) putting the shoreline and innovative sustainable design at the forefront
3) reconnecting the city to its waterfront
4) embracing and celebrating Seattle's past, present, and future
5) improving access and mobility
6) creating a bold vision that is adaptable over time
7) developing consistent leadership from concept to construction to operations

In October 2014, Seattle City Council cost estimates for the future waterfront totaled $1.07 billion, which includes improvements to the Alaskan Way Corridor ($400 million), Elliott Bay seawall ($331 million), overlook and east-west connections ($165 million), public piers ($94 million), Pike Place Market ($40 million), Seattle Aquarium ($34 million), and LID Administration ($6 million). An additional $253 million for required public utility work (Seattle City Light and Seattle Public Utilities), plus an undisclosed amount by private utilities, will be spent to accommodate the new waterfront improvements, resulting in a total package that totals $1.32 billion dollars above and beyond the tunnel costs. Funding sources include a Seawall Bond Measure, WSDOT and Pike Place Market partnerships, King County, Local Improvement Districts, parking taxes, a real-estate excise tax, LTGO bond proceeds, and philanthropic sources.

The conceptual design for the central waterfront strives to create a dynamic and lively public realm at the water's edge, build an intelligent and efficient transportation corridor to replace the Alaskan Way Viaduct, reestablish highly functioning ecosystems along the water's edge, develop a program of activities/uses, and promote economic development and sustainability while implementing "green" infrastructure in and around the central waterfront.

What Do Seattleites Want? In 2011, the City of Seattle began an extensive public outreach process to seek input and to help shape the look, feel, and function of Seattle's waterfront. Many people have participated in workshops and public meetings—such as the one pictured—or submitted ideas and comments in writing. A vast range of ideas have been obtained, and the design team is integrating these ideas into the overall concept for Seattle's future waterfront. (Courtesy City of Seattle.)

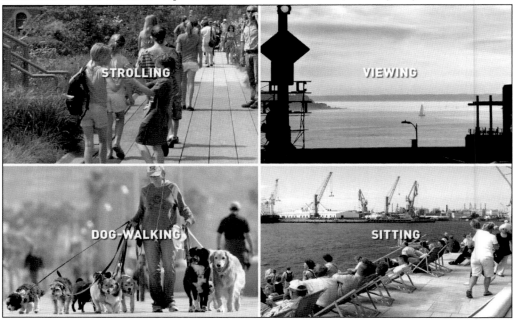

Seattleites Want Space for the People. Residents of Seattle want the ability to bike, stroll, walk dogs, sing, dance, eat, shop, sightsee, sail, dock, swim, and fish, as well as watch outdoor movies and attend outdoor concerts, all with a multimodal transportation hub. They want to be able to interact with nature. They want to be able to interact with each other. They want to touch the water and see wildlife. They want to see the views of the city. They want to see the view of water. They want something for everyone. (Courtesy City of Seattle.)

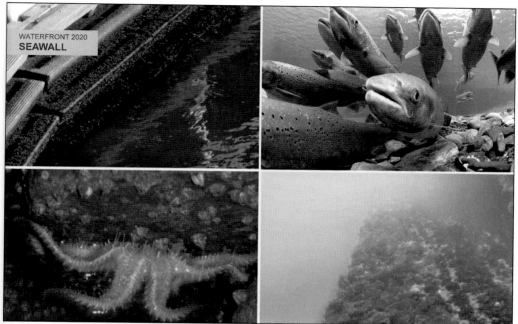

WATERFRONT 2020
SEAWALL

SEATTLEITES WANT TO CREATE HABITAT. They want the Elliott Bay Seawall to do more than keep out the water and hold up streets and sidewalks. They want to improve the ecosystem along the central waterfront. They want to improve the migration route for the thousands of juvenile salmon that travel along Seattle's waterfront on their journey from the Duwamish and Green Rivers to the ocean. They want to create sloping beaches, crevices, and vegetated hiding places for fish to safely migrate. They want sunlight to penetrate the water to help create a healthy ecosystem. They want improved water quality. They want the texture of the seawall to enhance habitat. They want to restore the function of natural shoreline characteristics and create a healthy foundation for the future. (Courtesy City of Seattle.)

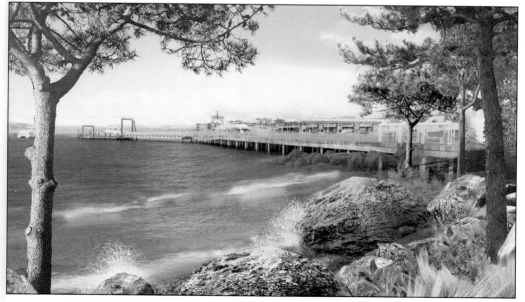

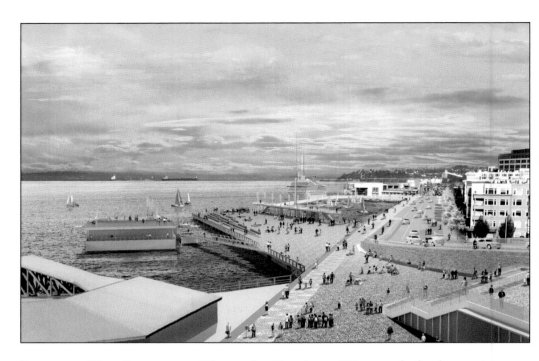

SEATTLEITES WANT INTERACTION. The people of Seattle say: "We want a built urban environment connecting with the natural environment. We want sustainability, mobility and accessibility for all." These images show an artist's rendition of Pier 62/63 looking west towards the water (above) and east towards the city (below), illustrating how the future waterfront will connect Seattle's urban environment to the natural environment. (Both, courtesy City of Seattle.)

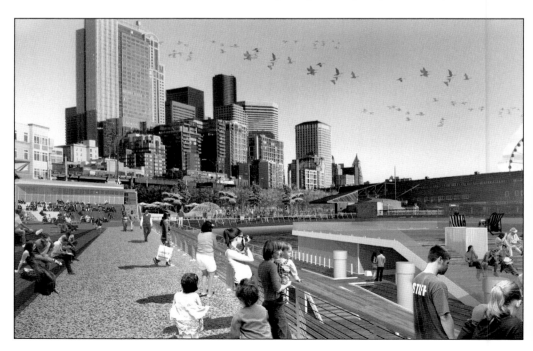

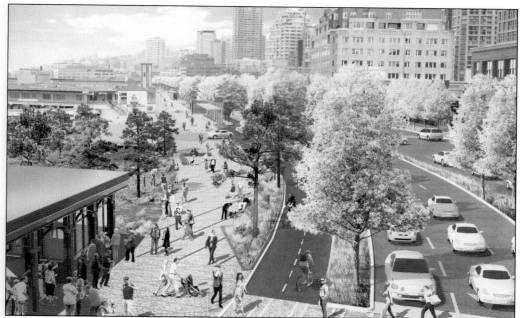

FUTURE VISION. The spirit of Seattle is ever strong, much like the pioneers who took the opportunity to re-create the city after the Great Fire of 1889. Today, Seattle recognizes the need to rebuild the seawall, and with the decision to replace the Alaskan Way Viaduct with a tunnel, Seattle is presented with the unique opportunity to create a space that helps to realize a strong vision—for today and for future generations. Seattle's future vision embraces the past, reconnects with nature in a sustainable fashion (much like the native Duwamish and Suquamish people), and maintains the working waterfront, while also strategically positioning the waterfront for future uses and needs. May the journey begin! (Both, courtesy City of Seattle.)

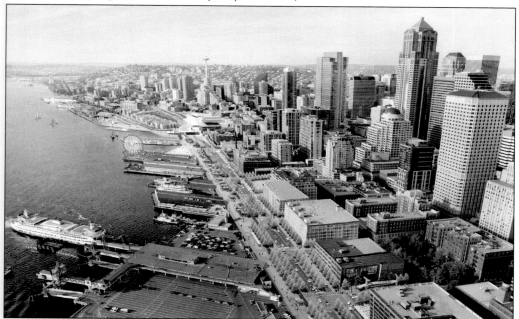

DISCOVER THOUSANDS OF LOCAL HISTORY BOOKS FEATURING MILLIONS OF VINTAGE IMAGES

Arcadia Publishing, the leading local history publisher in the United States, is committed to making history accessible and meaningful through publishing books that celebrate and preserve the heritage of America's people and places.

Find more books like this at
www.arcadiapublishing.com

Search for your hometown history, your old stomping grounds, and even your favorite sports team.